POSTCARD HISTORY SERIES

Reading

IN VINTAGE POSTCARDS

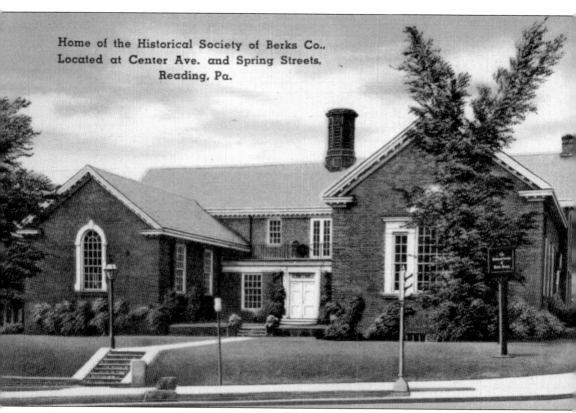

Home of the Historical Society of Berks Co.,
Located at Center Ave. and Spring Streets,
Reading, Pa.

THE HISTORICAL SOCIETY OF BERKS COUNTY. This landmark structure in Reading's Centre Park Historic District houses the museum, library, auditorium, and shop of the Historical Society of Berks County. The society is one of the largest and most active of its kind in Pennsylvania. With more than 20,000 historical artifacts, its museum features several permanent displays as well as a constantly changing exhibition gallery. Especially interesting to the visitors who come from around the world is the library's extensive genealogical collection.

POSTCARD HISTORY SERIES

Reading

IN VINTAGE POSTCARDS

Charles J. Adams III

ARCADIA
PUBLISHING

Published by Arcadia Publishing
Charleston, South Carolina

Printed in the United States of America

Library of Congress Catalog Card Number: 00105239

For all general information contact Arcadia Publishing at:
Telephone 843-853-2070
Fax 843-853-0044
E-mail sales@arcadiapublishing.com
For customer service and orders:
Toll-Free 1-888-313-2665

Visit us on the Internet at www.arcadiapublishing.com

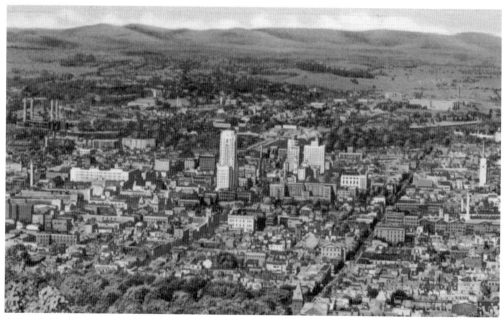

A BIRD'S-EYE VIEW OF READING FROM THE PAGODA. Over the years, millions of people have looked over the city from this vantage point. Much has changed since this c. 1937 view, but the Berks County Courthouse remains the tallest structure in the city. Note the broad expanses beyond the city that are now taken up by the western suburbs. (Lynn H. Boyer.)

CONTENTS

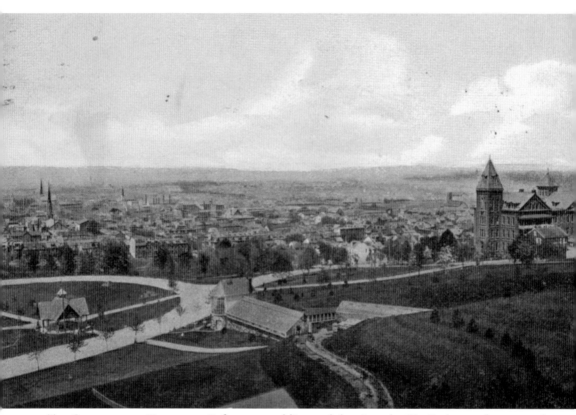

THE CITY FROM THE BOULEVARD. Before trees obliterated the view, the City Park greenhouses and St. Joseph's Hospital helped to frame this view of the city from the foot of Duryea Drive. Note the pavilion that once stood over the drinking fountain in the park on the far left. (A.C. Bosselman & Company.)

INTRODUCTION

Political rallies were being held where cars now speed along on a highway. Cows were grazing where multimillion-dollar mansions now stand. Revolutionary War prisoners were held where a pleasant park now creases a tranquil glen. Executions were carried out on gallows in a prison yard where children now romp on a playground. These and myriad more transitions from the past to the present are vividly depicted in the images within the pages of this book. What you will see here are visions of the past. It will be left to your imagination and exploration to discover what stands now in place of many of these long-gone landmarks.

As Reading emerged from the era of stage coaches, canal barges, and railroads and into the world of highways and high technology, the city evolved and its landscapes were forever altered. In this volume you will gaze upon buildings, bridges, street corners, and neighborhoods that may be seen only on rare photographs and the thousands of postcard views that were published in the first half of the 20th century.

What is *not* included among the images in this book are the scant details of where and by whom these postcards were published. It is remarkable just how many firms produced cards that were sold in Reading in the opening decades of the 20th century. At least 25 publishers are represented in this volume. Their offices and print shops were spread out anywhere from the Netherlands to England; Dresden to Leipzig, Germany; New York City and Chicago; as well as Easton, Philadelphia, and Reading, Pennsylvania.

As noted in the Epilogue, the history of the publication of postcards has been divided into seven parts. Most of the cards appearing in this book were printed from 1907 to 1914, in the Divided Back Era of postcard manufacturing. Reading printers had not yet begun to explore the postcard field.

Also included here are several cards from the so-called White-Border Era (1915–1930). During that time, several Reading printers began to dabble in the postcard printing business. Most notable was H. Winslow Fegley, whose efforts are well-represented in this collection.

During the Linen Era, which started in the 1930s and continued well into the 1950s, the leading local publisher was the Stichler Novelty Company, the cards of which appear often in this book. The Linen Era cards are noteworthy in that they were less costly to produce and, many collectors agree, were less appealing. Nonetheless, the era produced a profusion of new cards with new images that captured many scenes that would disappear during the rampant post–World War II development, redevelopment, and expansion of cities such as Reading. You will find several of those scenes in these pages.

You will also find pictures of a few structures and scenes that have survived the storms of progress. You will likely notice subtle to severe changes in their appearances. This book is a time capsule that you have chosen to add to your shelves. Open it and transport your mind to places that exist now only in volumes such as this. Not only are the pictures on these postcards interesting, so too are the peripheral annotations and the scars of time on many of them.

These postcards are presented with all their warts—the smudges, the cancellation stamps bleeding from the address side or accidentally emblazoned on the picture side, the tattered edges, and the dog-eared corners. But consider where these postcards have been before they came to grace the pages of this book. Somewhere, someone so many years ago picked out their favorite picture postcard, jotted down their special message to their special friend or relative, licked the back of a penny stamp, placed it on the card, and dropped it into a mailbox.

Later, another person in another place opened another mailbox and found that slim slip of cardboard with a lovely picture on one side and loving words on the other:

Wish you were down here to see the nice parks. Was up to Mt. Penn last week and had a fine time.

Bear's [see page 19] sure has some classy shoes.

May happiness crown your days.

The water is wet that flows out of the fountain of opposite side of card.

Father and mother will go home with you when you come down in the "auto" some Saturday—if you have room to take them.

Saw a great many black birds this eve—makes me think of fall and I hate to think of winter following. Suppose I'll strike out for Florida!

Please take care of my old man until I get home.

You may look for me, for I will be there.

With eager anticipation, the recipients read those words, gazed at that picture, and tucked that special card away among their treasures.

Through the years, those postcards survived to be handed down to generations of descendants. Then, some of them found their way into the postcard books, racks, and bins in flea markets, antique shops, and Internet auction services across the land. Their journey through the decades and across the miles has not yet concluded. Their destinations are not yet determined.

These snapshots of Reading's past only pause here, enshrined in print so you may share the same wonderment that their senders and receivers enjoyed so very long ago.

—Charles J. Adams III
Reading, Pennsylvania

One

PANORAMIC VIEWS

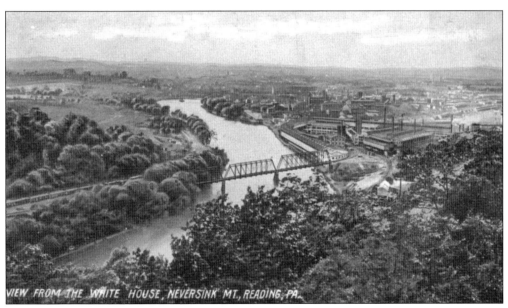

VIEW FROM THE WHITE HOUSE, NEVERSINK MT., READING, PA.

READING FROM THE SOUTH. Note the steel South Sixth Street Bridge and the outlet (Jackson's) lock of the Schuylkill Canal at the canal boatyards in the center of this view. Between the canal and the river was a strip of land called Long Island. The old Spruce Street railroad bridge seen here is gone, having been destroyed in the 1960s. The remains of its supports are still evident in the river. (Souvenir Post Card Company.)

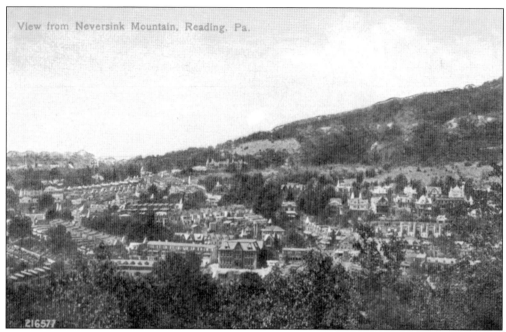

A VIEW FROM NEVERSINK MOUNTAIN. The city's eastern end spreads beneath the slope of Mount Penn. Note the Fifteenth and Perkiomen school in the center foreground. The school was consumed by fire in the 1960s, and the southeast branch of the Reading Public Library now stands on the site. (The Valentine-Souvenir Company.)

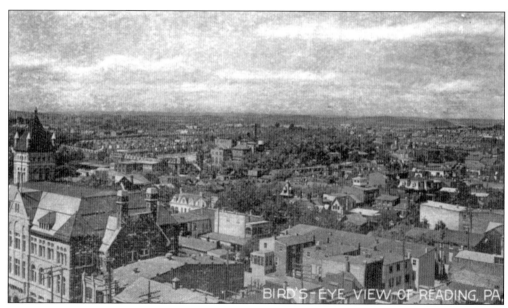

A BIRD'S-EYE VIEW OF THE CITY. This picture provides a fine view of the former Girls' High School in the left foreground. The school once stood on the northeast corner of Fourth and Court Streets and was the Girls' High School from its opening in 1896 to its closing in 1927. Later, it became Southwest Junior High School and then a special education school. It was razed in 1961. (J. George Hintz.)

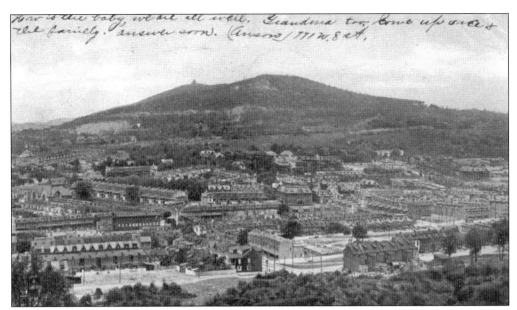

EAST READING FROM NEVERSINK MOUNTAIN. In a continuation of the card to the left, the tidy row homes of East Reading can be seen sprawling between Mount Penn and Neversink Mountain in this *c.* 1907 picture. Note the presence of the Tower Hotel atop Mount Penn in the distance. (J. George Hintz.)

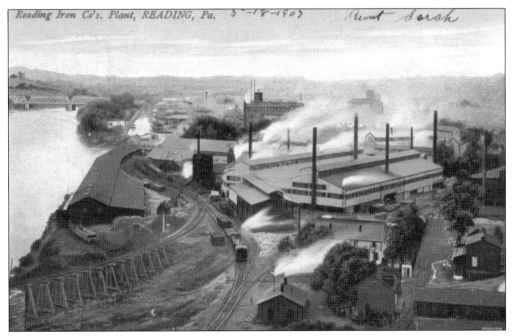

THE READING IRON COMPANY. Once the largest industry in Reading, the Reading Iron Company (established in 1889) sprawled at the foot of South Sixth Street. It was one of the country's leading supplier of wrought-iron tubes. The canal lock and Long Island are easily visible in this picture, as is the old iron truss Lancaster Avenue–Bingaman Street Bridge in the upper left. (Souvenir Post Card Company.)

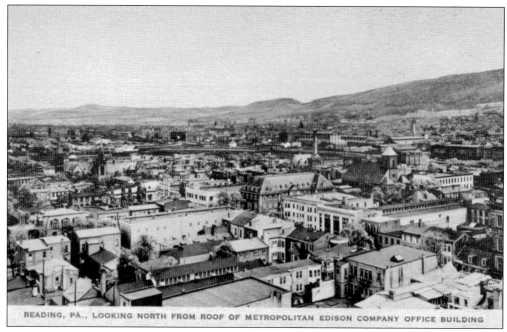

READING, PA., LOOKING NORTH FROM ROOF OF METROPOLITAN EDISON COMPANY OFFICE BUILDING

LOOKING NORTH FROM THE ROOF OF THE METROPOLITAN EDISON BUILDING. The Wyomissing Club and the St. John's German Lutheran Church are readily identifiable in this view of the city. Note, too, the railroad lines that converge at the Outer Station in the center of the picture. (Associated Gas & Electric System.)

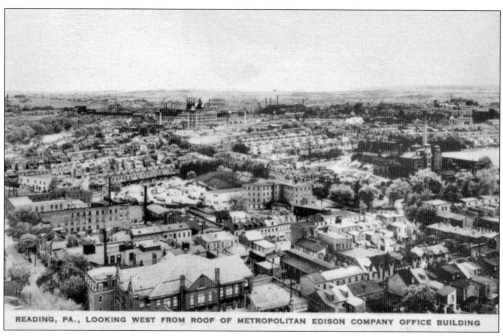

READING, PA., LOOKING WEST FROM ROOF OF METROPOLITAN EDISON COMPANY OFFICE BUILDING

LOOKING WEST FROM THE ROOF OF THE METROPOLITAN EDISON BUILDING. The northwest section of the city spreads out in this view taken from the top of the former Metropolitan Edison (now the Madison) building. (Associated Gas & Electric System.)

Two

PENN STREET

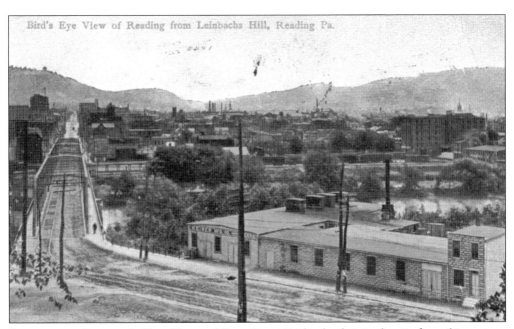

READING FROM LEINBACH'S HILL. The steel Penn Street Bridge leads into the city from this vantage point in West Reading. The Keiser Manufacturing Company (in the foreground) produced shears that were used around the world for shearing sheep. The West Shore Bypass now cuts through that site. On the city side of the river, a notable building is the former Penn Hardware Company building on the right. (A.C. Bosselman & Company.)

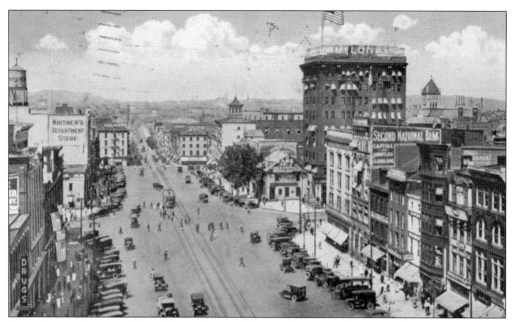

PENN SQUARE, LOOKING WEST. The undisputed heart of Reading's business district, Penn Square is abuzz with activity in this *c.* 1930 view. The tall building is the Colonial Bank Building (still a bank office building). The cupola-topped building to its left was Reading's first (six-story) "skyscraper," Mishler's Grand Central House. That hotel included a 1,000-seat theater. To the right of the Colonial Bank Building is the tower of the old Girls' High School. (Sabold-Herb Company.)

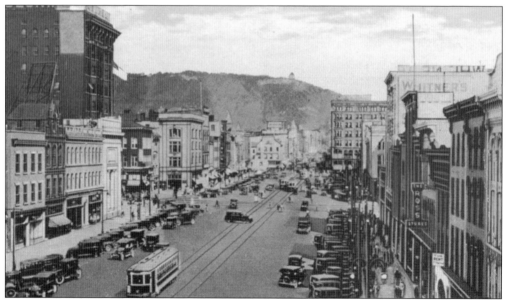

PENN SQUARE, LOOKING EAST. Traffic, trolleys, and pedestrians clog the city's main thoroughfare in this view that extends to the Pagoda atop Mount Penn. Interestingly, all of the buildings on the south side of the 400 block of Penn Street have survived since the late 19th century. (Sabold-Herb Company.)

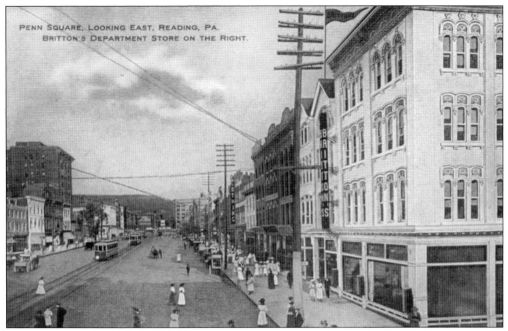

PENN SQUARE, LOOKING EAST. This view of the square was taken from the former American House Hotel at Fourth and Penn Streets. The building that then housed Britton's Department Store on the right is still standing, and its window treatments are highly regarded for their ornate charm. The G.M. Britton Company operated this department store in Reading and another in Pottsville.

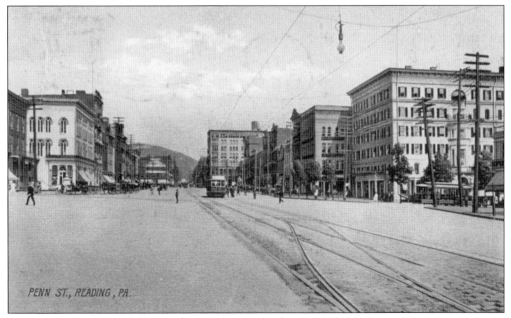

PENN STREET. Trolley tracks crease the broad expanse of Penn Square in this view looking toward the east. An important building in this picture is the Mansion House hotel to the right. (J. George Hintz.)

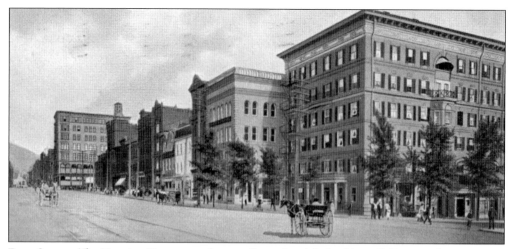

PENN SQUARE. The Mansion House stands proudly on the right in this *c.* 1913 view of a quiet Penn Square. The building adjacent to the big hotel once housed the Bright's Hardware store. (Hugh C. Leighton Company.)

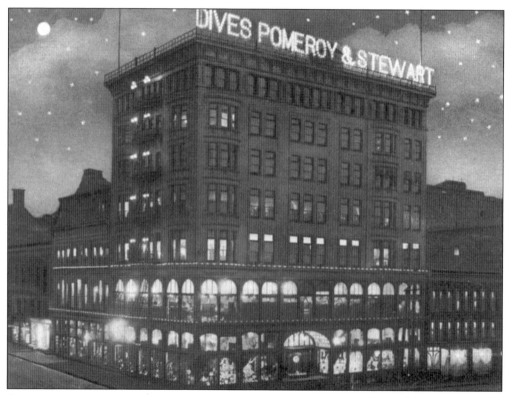

SIXTH AND PENN STREETS BY MOONLIGHT. Brightly decorated and brilliantly lit windows mark the city's premiere department store in this 1908 view. The First Union Building now stands on the site. The building pictured here was designed by renowned Reading architect Alexander Forbes Smith (1862–1939). Smith came to Reading from Scotland and gave to his adopted city not only his architectural talents but the game of golf. The area's first golf course was a six-hole layout at Carsonia Park. It lasted only one season.

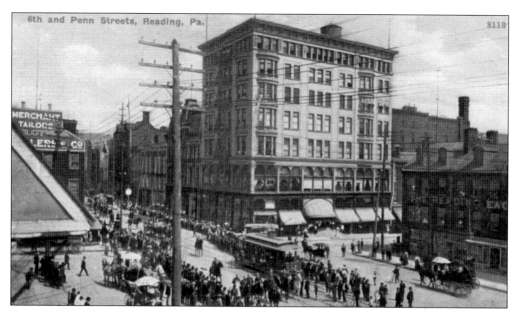

SIXTH AND PENN STREETS, THE SOUTHEAST CORNER. The Dives, Pomeroy & Stewart Department Store is the centerpiece of this view. Note the old Reading Eagle Company building to its right. The Reading Eagle Company occupied that site from 1868 to 1938. To the left of the large building is the original (1884) Dives, Pomeroy & Stewart store, which was built on the site of a place of early amusement for Readingites—Aulenbach's Hall. (A.C. Bosselman & Company.)

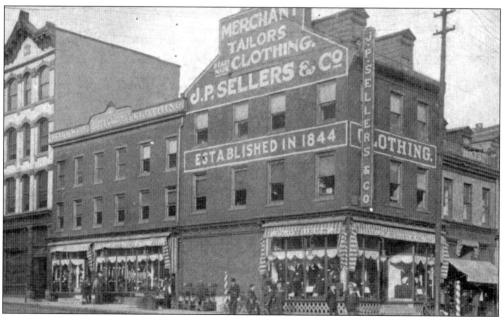

SIXTH AND PENN STREETS, THE NORTHEAST CORNER. The J.P. Sellers & Company clothing store once stood where the Berks County Bank Building now stands. At the far left is a building that once housed the offices of the *Berks & Schuylkill Journal*, a predecessor of the *Reading Times* newspaper. The shorter building was home to city's first daguerreotypists' shop, operated by Howard & Maurer.

17

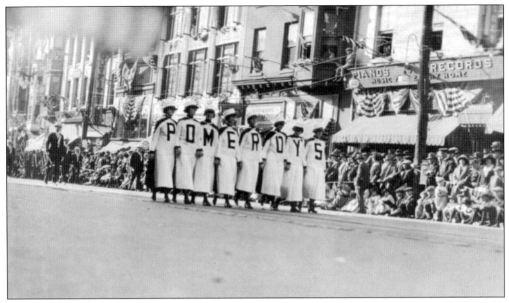

ON PARADE. A contingent from the Pomeroy's Department Store (successor to Dives, Pomeroy & Stewart) strolls Penn Street during a parade in this undated, but likely 1923 postcard view.

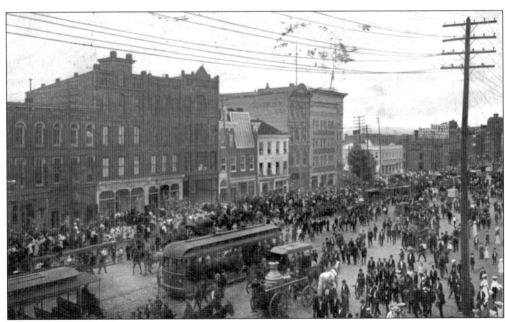

LABOR DAY ON PENN STREET. City fire equipment was among the major attractions at the annual Labor Day parade and gathering on Penn Square. The building with the unusual roofline in the center of the picture was a photographer's shop. The white panel was a specially designed skylight. This view is from *c.* 1908. (A.C. Bosselman & Company.)

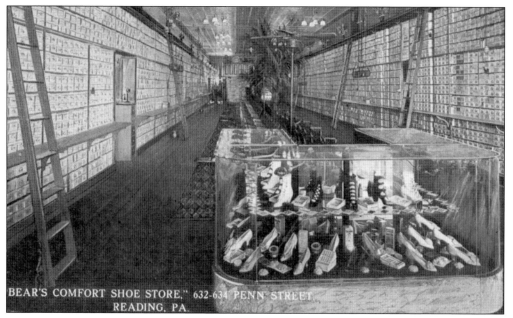

BEAR'S COMFORT SHOE STORE, C. 1912. They don't make 'em like this anymore. This well-stocked shoe store once served customers from its 632 Penn Street location. Barely visible in the upper center of the picture are tall palm trees, an adornment added to give the store style. (Leo Meyer.)

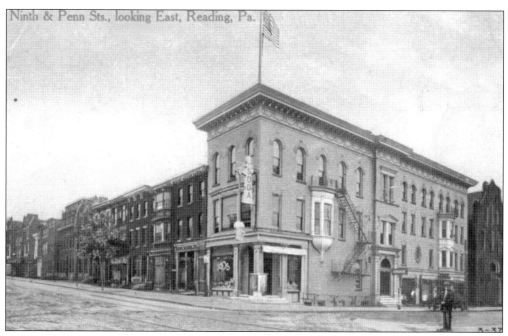

NINTH AND PENN STREETS, THE SOUTHEAST CORNER. Little has changed since this picture was taken in the early 20th century. What was a drug store then is a drug store now. Then, it was E.R. Mohler's Drug Store, and served as the ticket agency for rides on the Neversink Mountain Railway. (J. George Hintz.)

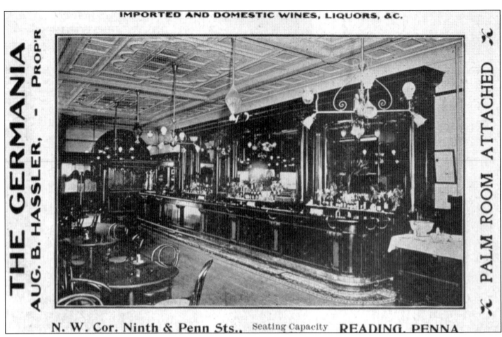

THE GERMANIA. Mr. Hassler's postcard just about says it all about his establishment. As a public service, the reverse side of the card listed the locations and numbers of every fire alarm box in the city. Incidentally, the tavern went through an understandable name change when World War I broke out. The building that housed it still stands on the northwest corner of Ninth and Penn Streets.

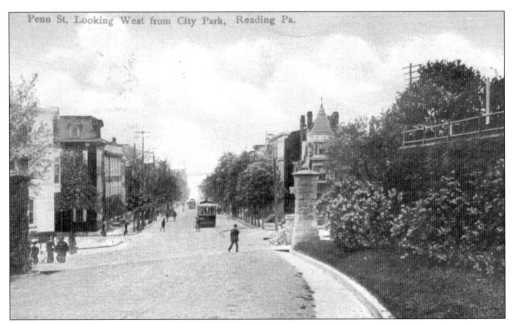

Penn St. Looking West from City Park, Reading Pa.

PENN STREET FROM CITY PARK. There was a time when traffic could continue east from Eleventh and Penn Streets into City Park. The stone pillar visible was one of several improvements made to the park in 1893. That corner of the park has since been reconfigured. (A.C. Bosselman & Company.)

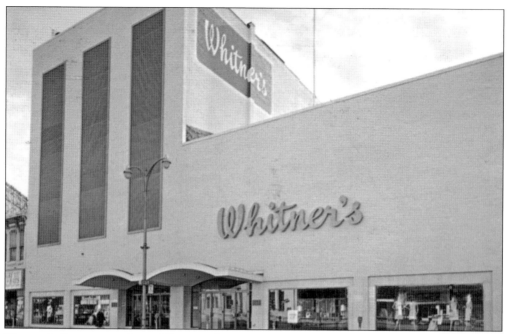

WHITNER'S DEPARTMENT STORE. This *c.* 1960s postcard shows the modernistic facade of Whitner's Department Store, long a major retailer on Penn Square. Known as the "White Store" downtown, the C.K. Whitner operation actually had its roots as a general store in the village of Spangsville. It survived as a local mercantile for 110 years. This facade was placed over the older front of the store. Known for putting the first escalator in Reading into operation on August 21, 1948, Whitner's closed in 1981. (Dexter Press Incorporated.)

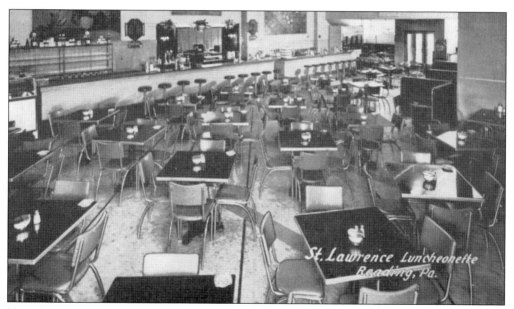

THE ST. LAWRENCE LUNCHEONETTE. This large and popular eatery once hosted customers at 535 Penn Street. It was owned and operated by the St. Lawrence Dairy. Its ice cream and soda fountain was understandably the most popular part of the operation.

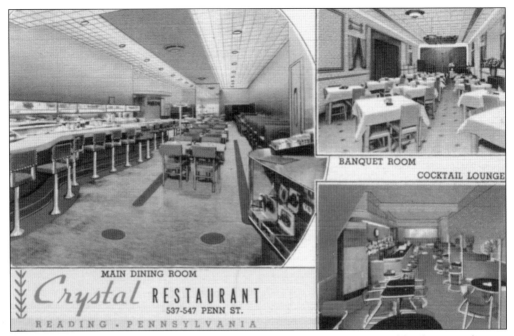

THE CRYSTAL RESTAURANT. At one time, the Crystal Restaurant was arguably the most famous and popular restaurant in downtown Reading. It once included a complex that featured a bar, meeting room, pastry shop, and restaurant. Established in 1911, what started as the Crystal Baking Company was destroyed by fire. (C-T Art-Colortone Postcards.)

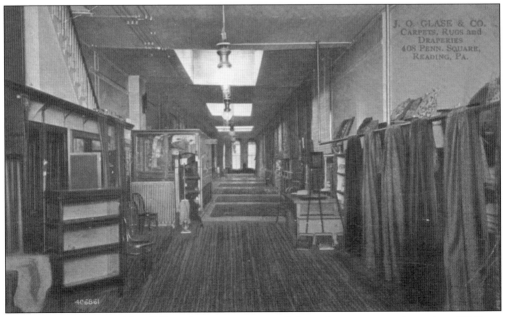

J.O. GLASE & COMPANY. This full-service rug, carpet, and draperies store was situated at 408 Penn Street. Glase began his business in the village of Oley as a general store before moving to the city in 1891 and concentrating on rugs, carpets, and draperies. (The Post Card Distributing Company.)

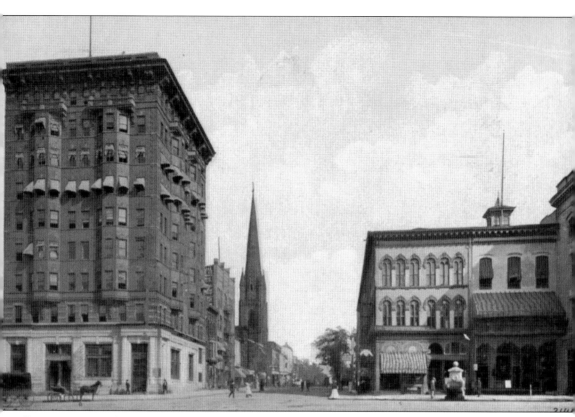

FIFTH AND PENN STREETS, THE NORTH SIDE. The Colonial Trust Company Building still towers over Penn Square and still serves as an important banking center. Note the Woman's Christian Temperance Union (WCTU) fountain in the lower right corner of this view. (Leighton & Valentine Company.)

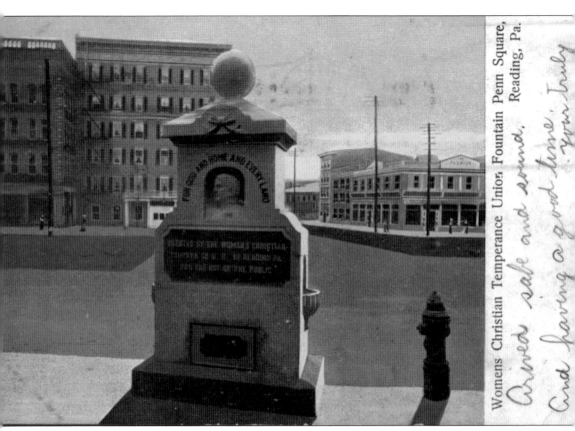

Womens Christian Temperance Union, Fountain Penn Square, Reading, Pa.

Arrived safe and sound, and having a good time. your truly

THE WCTU FOUNTAIN. This water fountain, erected by the Woman's Christian Temperance Union of Reading, still stands, but hasn't provided drinking water for many years. When it did, it was rather unique. An upper-level trough was used by horses. The fountain was used by humans, and a lower trough was used by cats and dogs. (Dives, Pomeroy & Stewart.)

Three

THE HOTELS

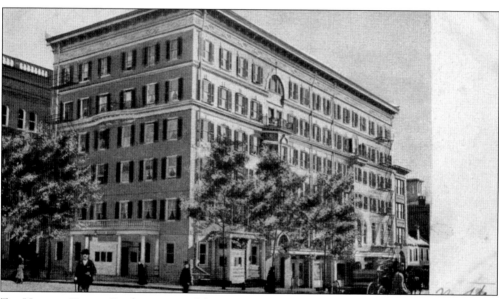

THE MANSION HOUSE. On the reverse of this British-published, Dutch-printed card is a brief history of what was once Reading's finest downtown hotel: "The lot on which the building is erected was conveyed by the Penns in January, 1765, for the yearly rental of eight pounds sterling. As it now stands, the Mansion House, a splendid Colonial building of brick and stone, contains 126 sleeping rooms, many with private baths." In its prime, such notables ranging from Edgar Allan Poe to several presidents stayed, dined, or visited there. On April 11, 1912, Pres. Theodore Roosevelt spoke from a porch of the hotel and drew a crowd of approximately 50,000—a figure that still stands as perhaps the largest single gathering ever on Penn Street. A previous version of the hotel was almost doubled in size in 1893 to this configuration. The Mansion House fell victim to the Depression and the presence of larger hotels that were built in downtown Reading. It closed in 1934 and was torn down in 1937 to make room for an elaborate bank building which was never built. Remnants of the lower level of the hotel still exist beneath a fast-food restaurant and other businesses on the southeast corner of Fifth and Penn Streets. (Raphael Tuck & Sons.)

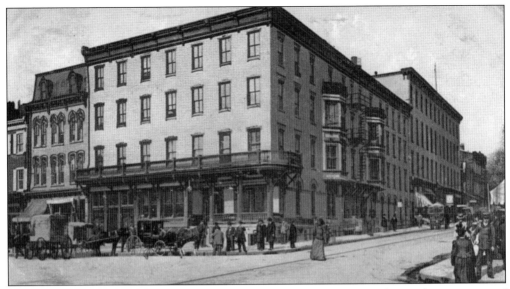

THE HOTEL PENN. This popular hotel was once the anchor structure on the northwest corner of Sixth and Penn Streets. Through its long existence, the operation was known as the Keystone House, the Pennsylvania House, and the Milner Hotel. Known by the latter name when it closed in 1948, the structure was eventually deemed structurally unsound and was demolished in the 1950s. Note the large building to the rear of the hotel. It was the Keystone Opera House, which presented world-class entertainment to the Reading public, including an 1871 lecture by Mark Twain. (The American News Company.)

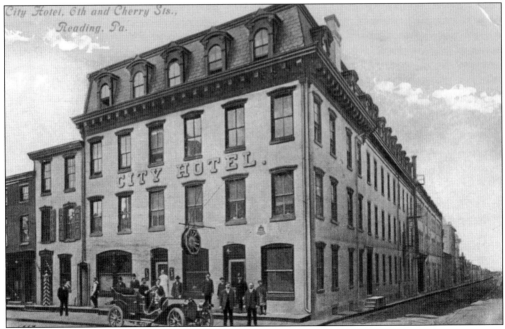

THE CITY HOTEL. Another old hotel in downtown Reading was the City Hotel, on the southwest corner of Sixth and Cherry Streets. It was constructed on the site of one of the first breweries in Reading and had 75 guest rooms within its walls. (A.E. Hildebrand.)

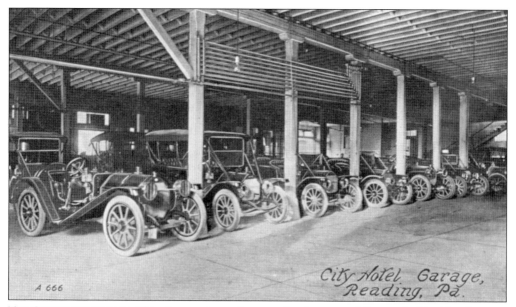

The City Hotel Garage. This view captures the era of early automobiles parked inside what was once the largest horse and carriage stable in the city. (A.E. Hildebrand.)

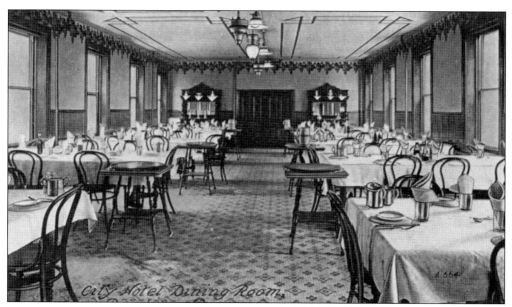

The City Hotel Dining Room. Used for many social and civic events, this dining room was known for its understated elegance. In a contemporary advertisement, its owners boasted that the 125-seat dining room featured "cuisine that is all that the most fastidious Epicurean could desire." (A.E. Hildebrand.)

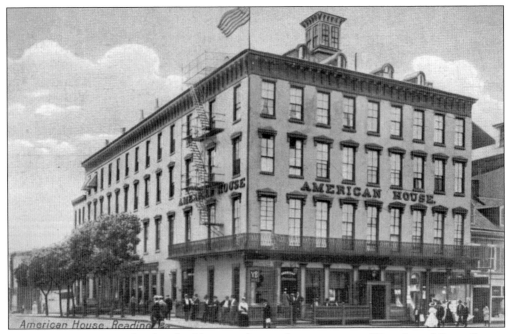

THE AMERICAN HOUSE. This fine building on the southwest corner of Fourth and Penn Streets still stands and was marvelously restored to what it looked like in this *c.* 1912 picture. Built in 1851–1852, the building played host to the earliest agricultural exhibits, predecessors to the Reading Fair. (The American House.)

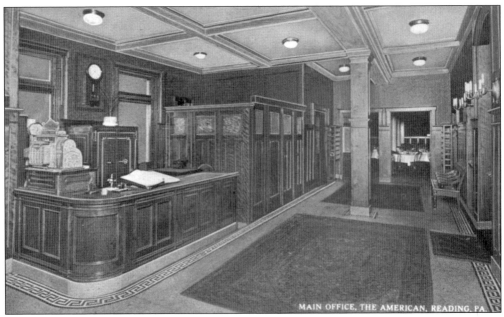

THE AMERICAN HOUSE OFFICE. Note the elaborate cash register at the left. In 1888, an advertisement for the American House listed its rates as "$2 a day." (Leo Meyer.)

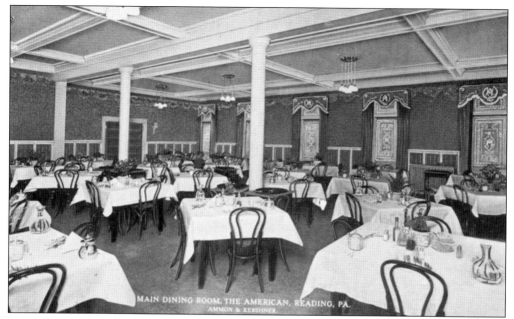

THE AMERICAN HOUSE DINING ROOM. Visible here on the window drapery is the stylish AH logo of the popular hotel. (Leo Meyer.)

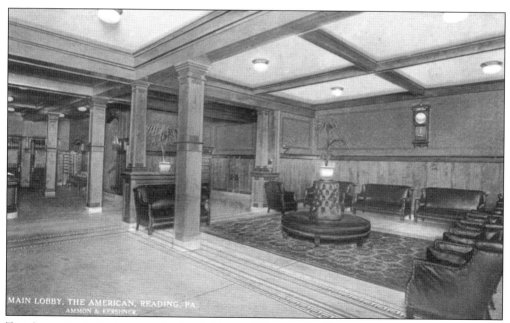

THE AMERICAN HOUSE LOBBY. In this lobby, well-known Reading "pyrologist" Irvin S. Herbein showed the first movies ever seen in Reading. He thrilled locals to flicks presented on his hand-cranked projector around the turn of the 20th century. (Leo Meyer.)

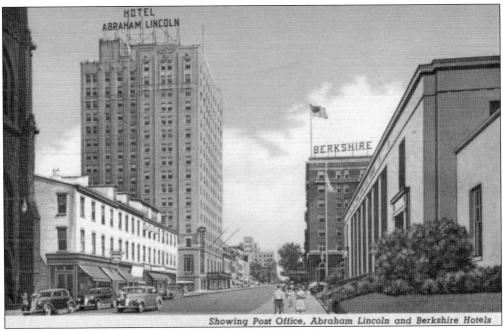

Showing Post Office, Abraham Lincoln and Berkshire Hotels

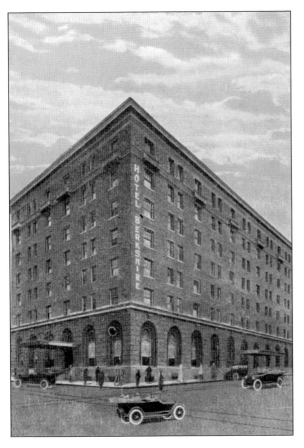

LOOKING TOWARD FIFTH AND WASHINGTON STREETS. The major buildings in this view—Christ Church, the Hotel Abraham Lincoln (now the Lincoln Plaza), the Berkshire, and the post office—still survive since this linen-textured postcard was released. However, the low row of businesses to the left have been replaced by a bank building. That row, originally residences, predated the Revolutionary War. Area historians were angered when it was learned that after the buildings were demolished, many of their architectural appurtenances were exported for historical restoration projects in the Society Hill section of Philadelphia. (Lynn H. Boyer Jr.)

THE HOTEL BERKSHIRE. This former hotel building at Fifth and Washington Streets has since been converted into a multi-use structure. (K.O. Kropp Company.)

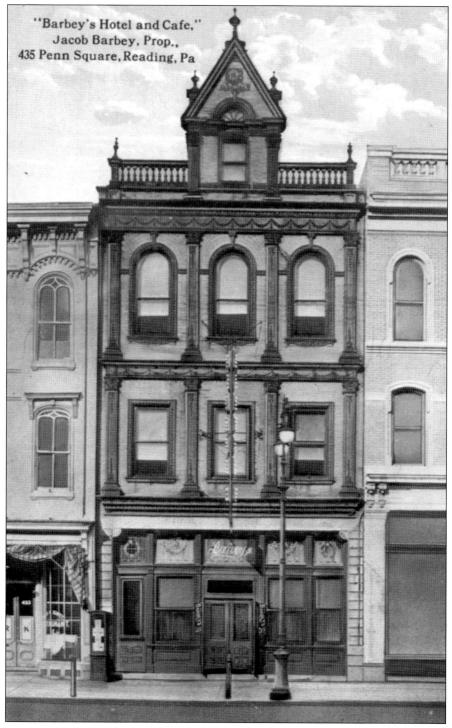

"Barbey's Hotel and Cafe,"
Jacob Barbey, Prop.,
435 Penn Square, Reading, Pa

BARBEY'S HOTEL AND CAFE. Once a handsome structure and popular hotel and restaurant, this 435 Penn Square facility was located adjacent to the former Consumers Gas Company, which can be seen to the right. (Leo Meyer.)

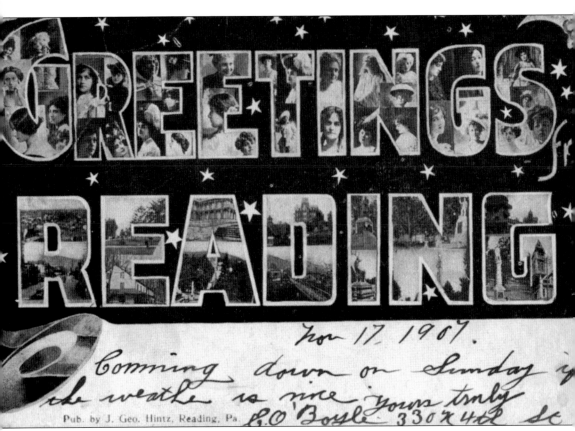

Nov 17, 1907.
Comming down on Sunday if
the weather is nice. yours truly
E. O'Boyle 330 x 44 St

GREETINGS! This general greeting card was sent from Reading in 1907. Note that at that time—that is, the so-called Undivided Back Era of postcard printing—it was illegal to write any message on the address side of a card. The "stamp" side of the card could only bear the name and address of the recipient. (J. George Hintz.)

Four

THE PARKS

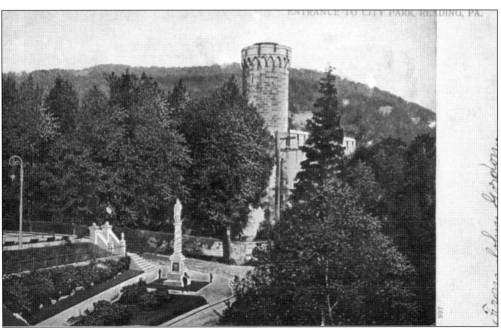

THE CITY PARK ENTRANCE. This 1906 view incorporates the Volunteer Firefighters' Memorial, the steps to the park reservoir, and the old prison tower. Note, however, that there is no Pagoda atop Mount Penn—it was not yet completed when this picture was taken. (A.C. Bosselman & Company.)

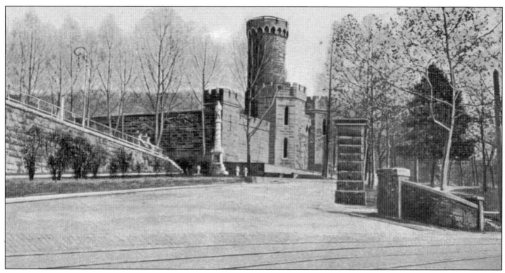

THE CITY PARK ENTRANCE, SCENE TWO. The reverse of this card reads, "City Park is considered one of the finest parks in the country. The locality was first improved for park purposes in 1878, and since then, over $125,000 have been expended on it. What is considered the main entrance is at the head of Penn Street." Note on this card a fine view of the Norman-style Berks County Prison. Hangings of convicted criminals were once carried out on the prison grounds. (Raphael Tuck & Sons.)

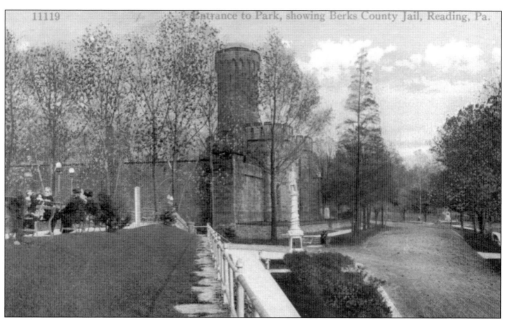

THE CITY PARK ENTRANCE, SCENE THREE. Shown is still another angle of the entrance to City Park as it was c. 1907. This view shows how the roadways were configured around the castlelike Berks County Prison and into the park. The prison was built in 1847 and closed when the present Berks County Prison was opened in Bern Township in 1932. The city prison, including its 96-foot high tower, was razed in the late 1930s, but its front steps survive to this day. (The Post Card Distributing Company.)

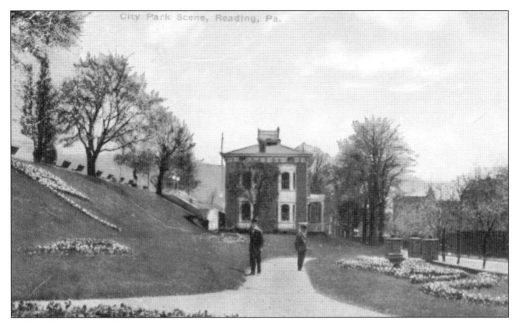

A City Park Scene. The Reading Bureau of Water building is the centerpiece of this picture. That building still stands, and serves as the headquarters of the Berks County Conservancy. Note, however, that something is missing from this scene as it appears today. That missing item would not appear until about five years after this *c.* 1909 picture was published. Find out what it is in the next postcard view.

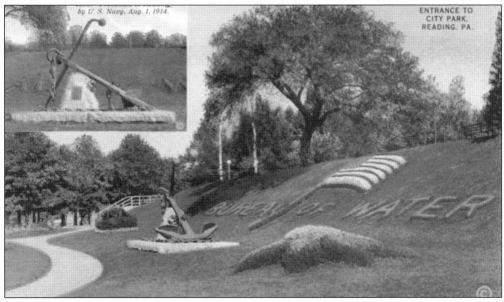

The Anchor of the Battleship USS *Maine*. A lightly regarded political figure named Franklin D. Roosevelt (serving then as undersecretary of the navy) dedicated the placement of this anchor from the USS *Maine* in Reading City Park on August 1, 1914. Although not surrounded by such elaborate gardens as this today, the anchor still stands in the first block of North Eleventh Street in City Park. (H. Winslow Fegley.)

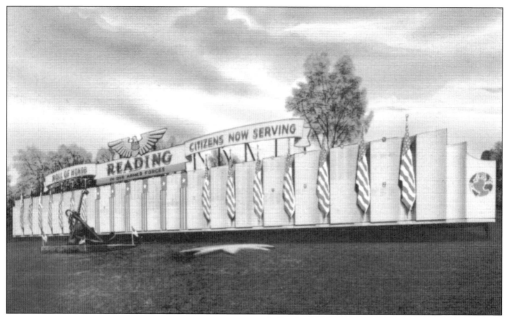

THE ROLL OF HONOR. The USS *Maine* anchor is dwarfed by the Roll of Honor of Reading Servicemen, erected during World War II in City Park. (Berkshire News Company.)

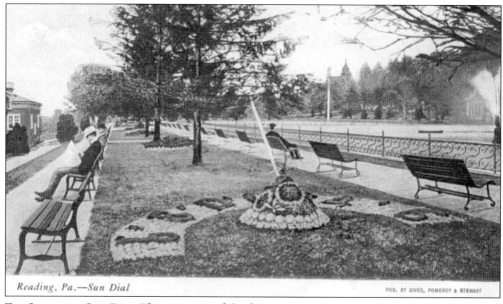

Reading, Pa.—Sun Dial

PUB. BY DIVES, POMEROY & STEWART

THE SUNDIAL IN CITY PARK. The presence of the former water bureau building on the far left and the tower of St. Joseph's Hospital that peeks over the trees just to the right of center will give some idea as to where this floral sundial was once located along the former reservoir (now basketball courts) in City Park.

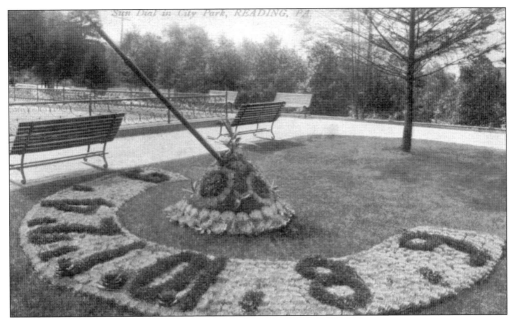

THE SUNDIAL, SCENE TWO. This is a closer look at the sundial that once stood in City Park. It was taken away when the reservoir (seen in the background) was covered in 1910. (Souvenir Post Card Company.)

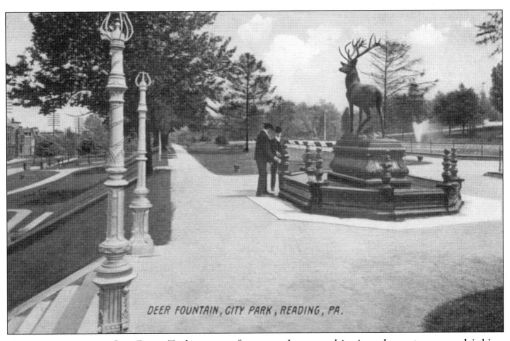

DEER FOUNTAIN, CITY PARK, READING, PA.

THE DEER FOUNTAIN, CITY PARK. Truly a scene from another era, this view shows two men drinking from common cups, which were chained to the drinking fountains of this park landmark. It is interesting to note that the fountain provided filtered ice water to park visitors as its waters passed through packs of ice between the reservoir (background) and the drinkers. (The Rotograph Company.)

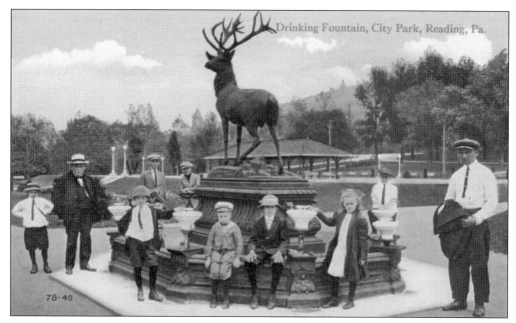

THE DEER FOUNTAIN, SCENE TWO. In this later picture are actual water fountains in which drinking water bubbled into the mouth directly—rather than drinking from common cups. Note, too, the new pavilion in the background. Although it was called the Deer Fountain, it was also known to locals as the "Elk Fountain."

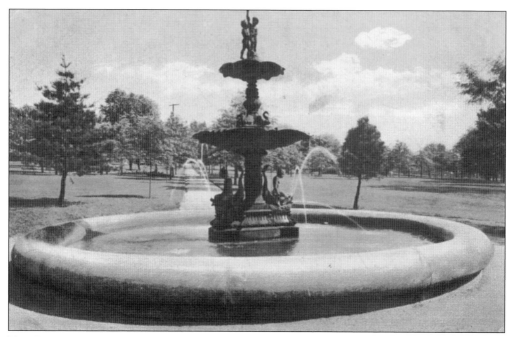

THE CITY PARK FOUNTAIN. Note the sizes of the trees in this *c.* 1906 picture. Also note the long promenade that extended from the fountain. (The Rotograph Company.)

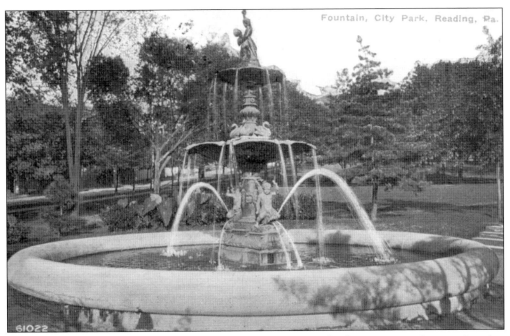

THE CITY PARK FOUNTAIN, SCENE TWO. This is a closer look at the fountain, a park attraction that was demolished many years ago. The flat ground on which it stood is still obvious just beyond the Perkiomen Avenue and Hill Road corner entrance to the park.

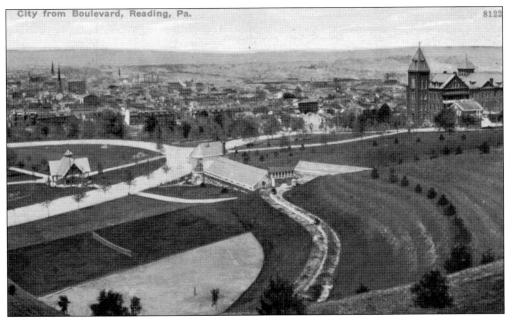

City from Boulevard, Reading, Pa. 8122

CITY PARK, THE NORTH END. Similar to an earlier view in this collection, this picture better depicts the lawn tennis court that stood next to the city greenhouse and the remnants of the Augustus Follmer vineyards and orchards that once graced the hillside to the right. The roadway that loops around on the left is now Constitution Boulevard. It owes its curvaceous course to the fact that it was once a race track. (A.C. Bosselman & Company.)

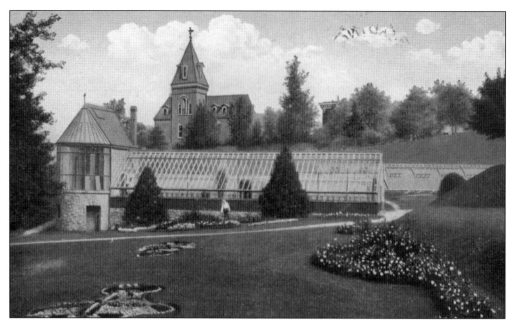

THE CITY PARK GREENHOUSE. This card shows a fine view of the lush grounds that surrounded the greenhouse and the original St. Joseph's Hospital, which towers over the park.

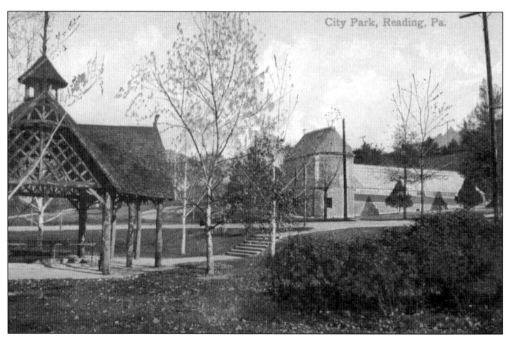

THE RUSTIC DRINKING FOUNTAIN. A lesser version of the drinking fountain still stands in city park, but the timbers of the pavilion have long since fallen. (The Valentine & Sons Publishing Company.)

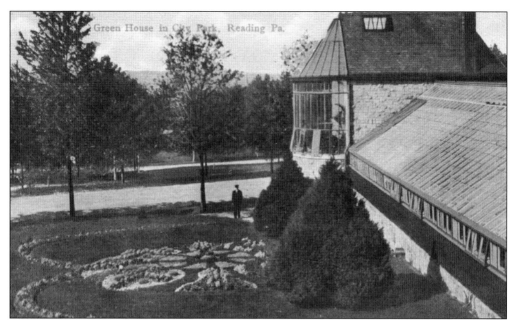

THE CITY PARK GREENHOUSE, SCENE TWO. The portion of the greenhouse to the right still stands in City Park, but the large front structure fell victim to decay and was demolished several years ago. (A.C. Bosselman & Company.)

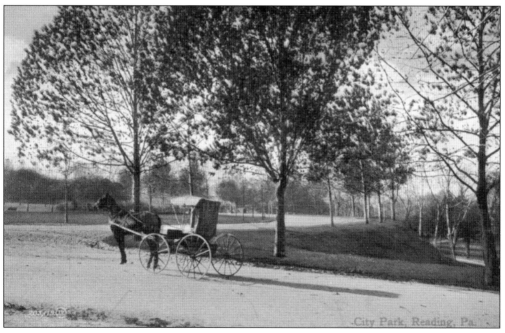

A QUIET DAY IN THE PARK. A lone carriage makes its way into City Park in this early-20th-century view. (The Valentine & Sons Publishing Company.)

41

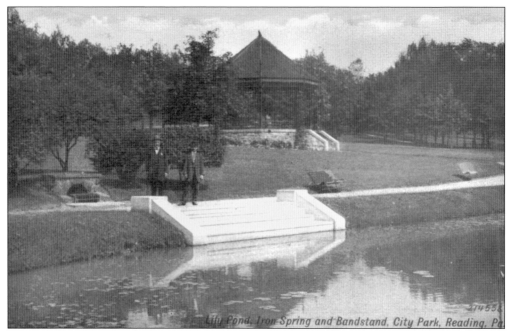

LILY POND, IRON SPRING, AND THE BANDSTAND. To give perspective to this view, note that the band*stand* (built in 1897) stood where the audience benches that face the band*shell* (built in 1939) now stands. (The Post Card Distributing Company.)

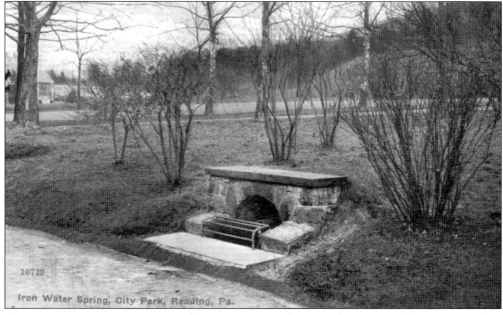

THE IRON WATER SPRING. As seen in the previous view, the spring housing is still in existence, but it is no longer a source for drinking water. (A.C. Bosselman & Company.)

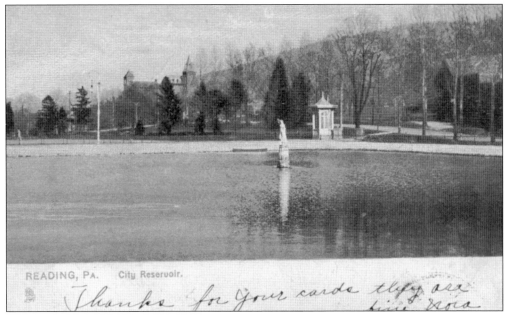

READING, PA. City Reservoir.

Thanks for your cards they are [illegible]

THE CITY RESERVOIR. This sweeping view of the City Park Reservoir features the 5-foot-high sculpture called *Hebe* on the waters of the reservoir. The bronze piece represented the goddess of youth and cupbearer to the gods. It also covered over the rather utilitarian pipes that kept water flowing into the reservoir. Also note the eight-sided park guard booth visible in this picture. (Raphael Tuck & Sons.)

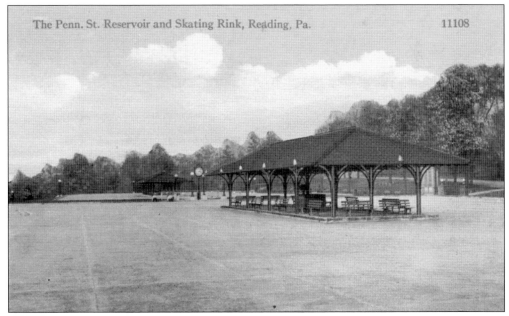

The Penn. St. Reservoir and Skating Rink, Reading, Pa. 11108

THE CITY RESERVOIR, COVERED. In order to provide more recreational space in City Park, the reservoir was covered in 1910 and converted into a skating rink. (The Post Card Distributing Company.)

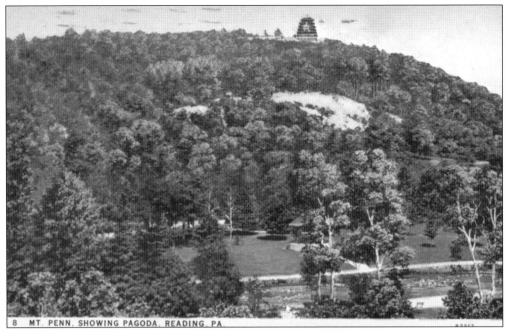

MOUNT PENN, FROM CITY PARK. Note the star affixed to the Pagoda in this sweeping, *c.* 1920 view of the mountain and park. (Sabold-Herb Company.)

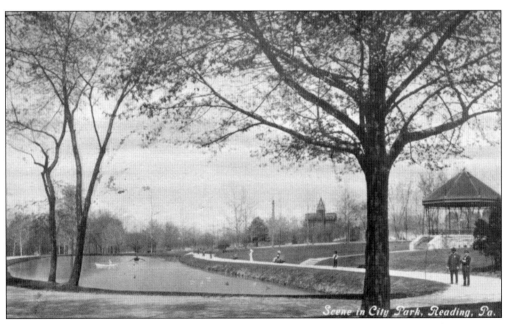

THE LILY POND, CITY PARK. Another view of the Lily Pond is shown here with rowboats on its waters. Those boats, however, may well have been created by the imagination of the artist-colorizer of this card, according to at least one Reading historian.

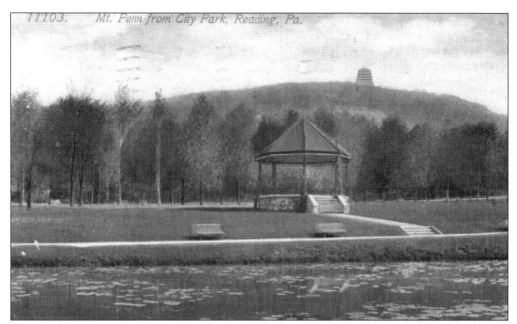

LILY POND AND THE BANDSTAND. This view of the lily-laden pond is roughly from the site of the present bandshell in City Park. (The Acmegraph Company.)

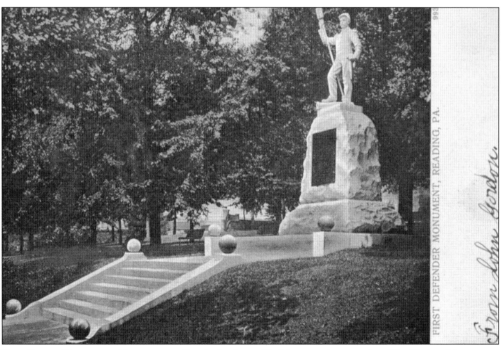

THE FIRST DEFENDER MONUMENT. Erected along Perkiomen Avenue in City Park, this statue commemorates the Ringgold Light Artillery of Reading, one of the first units to enter and defend Washington, D.C., in the earliest days of the Civil War. The statue was dedicated on July 4, 1901. (A.C. Bosselman & Company.)

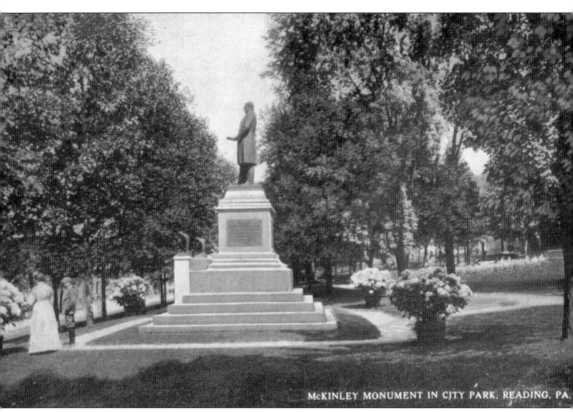

MCKINLEY MONUMENT IN CITY PARK, READING, PA.

THE PRES. WILLIAM MCKINLEY MONUMENT. On "monument row" along Perkiomen Avenue, this statue was erected to honor the martyred (1901) president. Much of its funding came from "penny, nickel, and dime" donations from city schoolchildren.

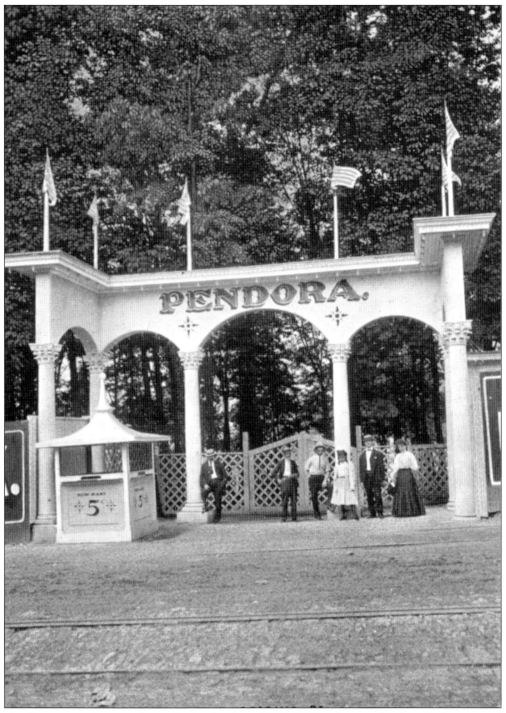

THE ENTRANCE TO PENDORA PARK. During its short (1907–1911) existence, Pendora Park competed with Carsonia Park for Reading's amusement dollars. This entrance gate stood near the corner of Nineteenth Street and Perkiomen Avenue and was one of two gateways to the park; the other was at Eighteenth Street and Mineral Spring Road.

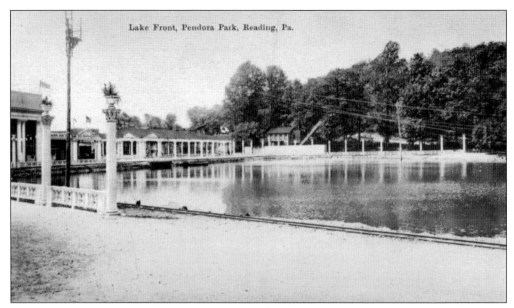

Lake Front, Pendora Park, Reading, Pa.

PENDORA PARK LAKE FRONT. Note the miniature railway train tracks visible on the foreground shore of the small lake that once graced Pendora Park. The land is now covered by the baseball diamonds at the city park of the same name. (J.G. McCrorey & Company.)

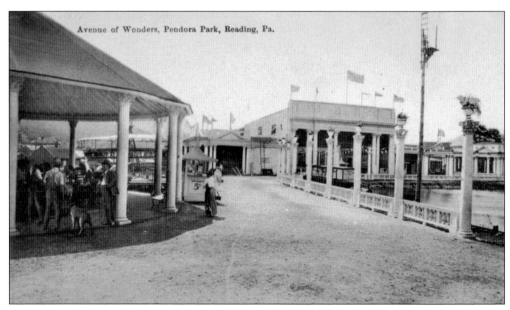

Avenue of Wonders, Pendora Park, Reading, Pa.

THE "AVENUE OF WONDERS." A roller rink, the Shoot-the-Chutes ride, a steam train line, a carousel, and other rides wrapped around the Lagoon (lake) at Pendora Park. The park was well known for its "Roman Columns," seen in this c. 1908 picture. (J.G. McCrorey & Company.)

48

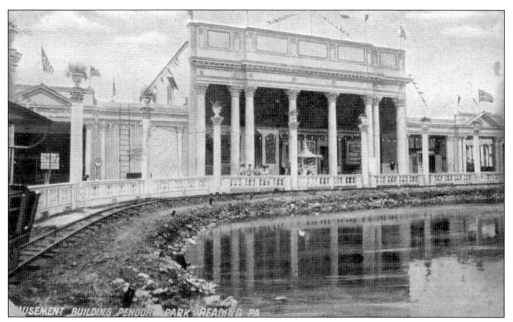

THE AMUSEMENT HALL. Pendora Park enjoyed a short but lively existence in East Reading. A fire in January 1911 broke out at the park skating rink and swept through most of the park, destroying all in its path. It is generally believed that the fire was the work of an arsonist.

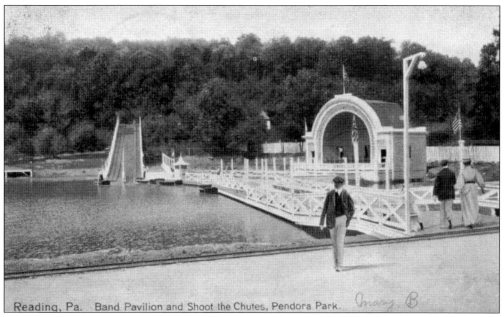

THE BANDSTAND, PENDORA PARK. The site of popular shows and concerts, the park's band pavilion stood adjacent to the Shoot-the-Chutes ride, seen on the left. The bandstand survived the 1911 fire, but was torn down shortly after the blaze. (The Hugh C. Leighton Company.)

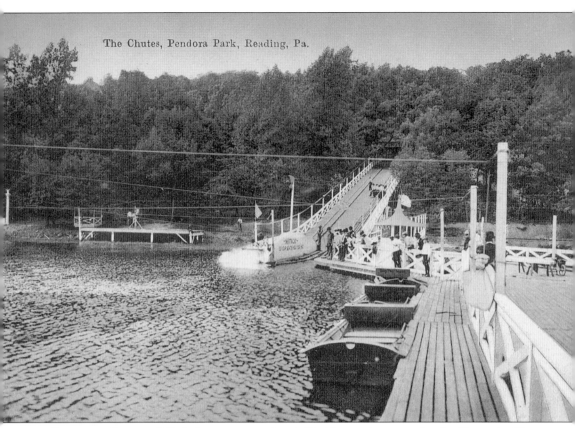

The Chutes, Pendora Park, Reading, Pa.

SHOOT-THE-CHUTES. Called the most popular thrill ride on the grounds, the Shoot-the-Chutes ride could be considered a forerunner of the popular rides at modern-day water theme parks. (J.G. McCrorey.)

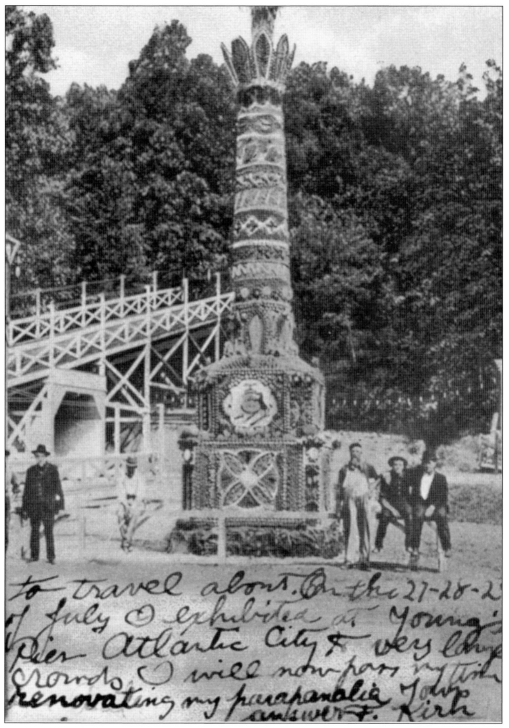

THE FRUIT COLUMN. More than 35 feet high, this pillar of fruit was one of the curiosities that intrigued Readingites during the brief existence of Pendora Park from 1907 to 1911. (A.C. Bosselman & Company.)

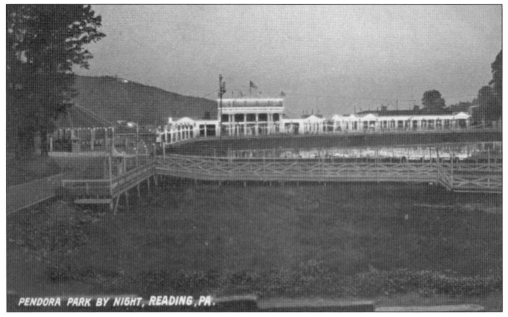

PENDORA PARK BY NIGHT, READING, PA.

PENDORA BY NIGHT. Its designers created Pendora Park to be dazzling at night, as witnessed in this view of the main Amusement Hall in 1908. By day, the park was often referred to as "the White City," owing to the fact that every building was painted white. After the 1911 fire (the park's owners had no insurance), the ruins were removed and the park later became a city playground.

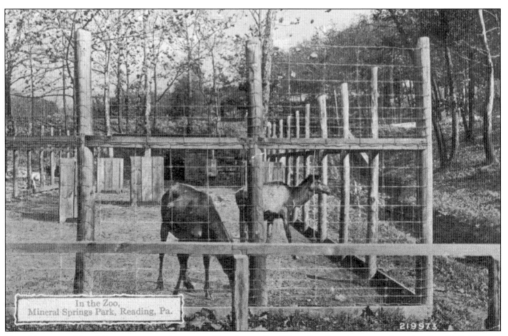

In the Zoo, Mineral Springs Park, Reading, Pa.

THE READING ZOO? It was more just a collection of wild animals given to the city by Col. Henry W. Shoemaker in 1913. They were exhibited at Pendora Park until the spring of 1924, when the city decided that the menagerie was too difficult to manage, and the beasts were donated to the Williamsport Zoo. (The Post Card Distributing Company.)

ENTRANCE TO MINERAL SPRINGS PARK, READING, PA.

THE MINERAL SPRINGS PARK ENTRANCE. Just north of Pendora Park (and now under the Lindbergh Viaduct), these walls and columns marked the entrance to one of the city's most beautiful parks around the turn of the 20th century.

Reading, Pa. Mineral Spring Park.

THE PROMENADE. Folks from Reading found a quiet and scenic retreat in the Rose Creek Valley east of downtown. The city park there was named Mineral Spring (also called Mineral *Springs*) after the spring waters there, which were thought to have curative powers. (Hugh C. Leighton Company.)

53

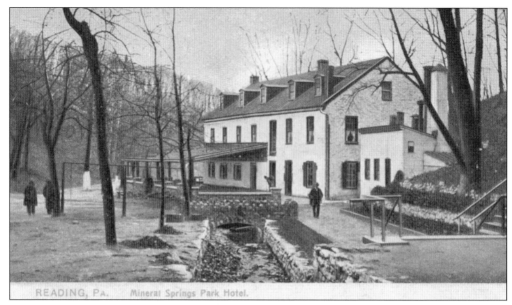

THE MINERAL SPRINGS PARK HOTEL. Built as a textile mill in 1815, the structure was modified and converted into a hotel three years later. In 1937, the East End Athletic Club purchased it and maintains its bar and restaurant there today. (Raphael Tuck & Sons.)

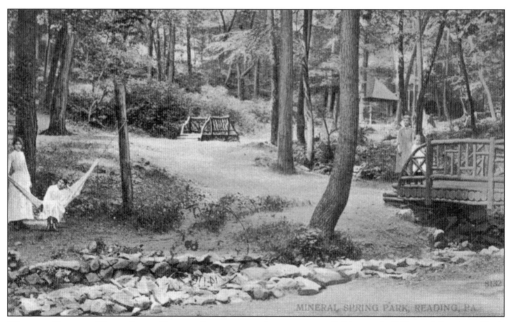

MINERAL SPRINGS PARK. According to the text on the reverse of this card, "Mineral Springs Park is one of the pleasure resorts frequented by the young people because of its attractions, such as dancing, etc. Mineral Springs Park, containing 64 acres, is beautified by annual appropriations exceeding $10,000." (A.C. Bosselman & Company.)

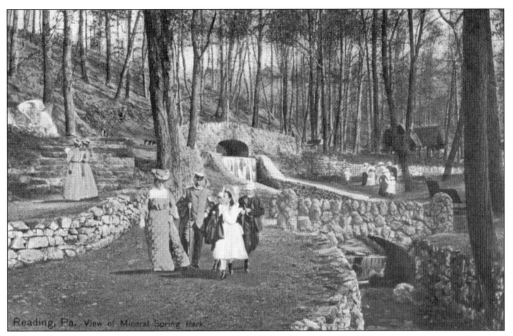

THE WATERFALL. A family strolls along one of many lanes among the springs and woods of Mineral Springs Park. The park was a frequent site of local and state political rallies. (J. George Hintz.)

CARSONIA PARK. This early view of Carsonia Park includes a glimpse of the park theater to the far left. This roadway evolved into the midway of the popular park, which was located in what is now Pennside. Carsonia Park opened in 1896 and was situated at the end of the Reading Street Railway Company line. (The American News Company.)

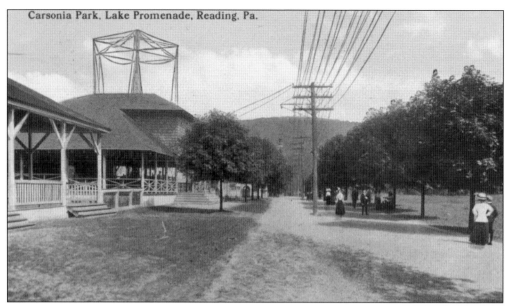

Carsonia Park, Lake Promenade, Reading, Pa.

LAKE PROMENADE. Noteworthy in this view of Carsonia Park is the bumper-car pavilion and the towering Circle Swing.

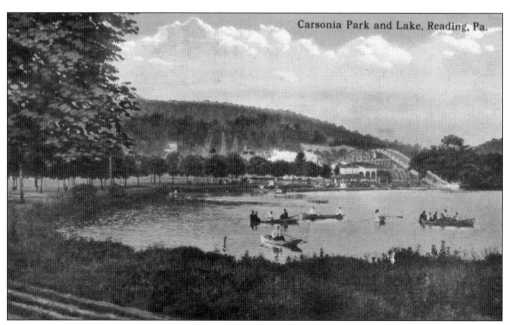

Carsonia Park and Lake, Reading, Pa.

CARSONIA PARK. As seen from the southeastern end of the park, "Crystal Lake" (now Carsonia Lake) is framed by rides and attractions of the popular amusement park.

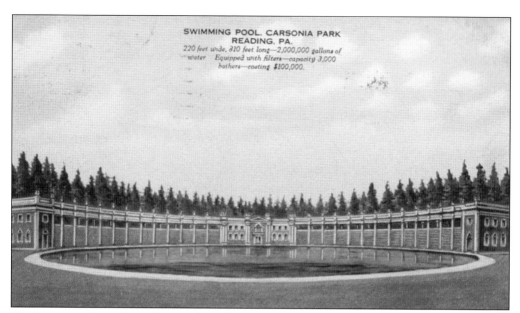

SWIMMING POOL. CARSONIA PARK
READING. PA.
220 feet wide, 310 feet long—2,000,000 gallons of
water Equipped with filters—capacity 3,000
bathers—costing $100,000.

THE CARSONIA PARK POOL. As stated on this card, the Carsonia Park pool was 220 feet wide, 310 feet long, and contained 2 million gallons of water. Once a refreshing place at the old Carsonia Park, the pool survives today in greatly modified form as the Antietam Pool in Pennside. (H. Winslow Fegley.)

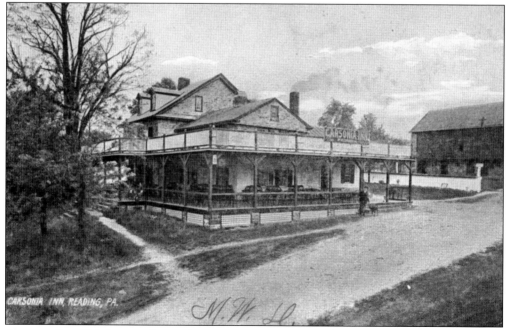

CARSONIA INN. This inn was known best in its time (1898–1914) for its clambakes. The building stood roughly between where Emerald and Harvey Avenues are today. It was razed in 1953 for the Pennside residential development. (J. George Hintz.)

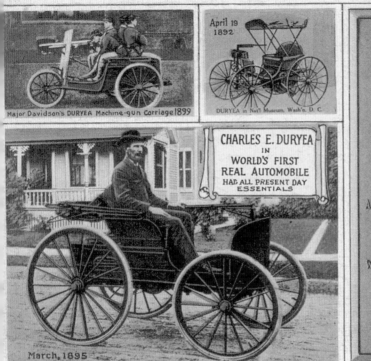

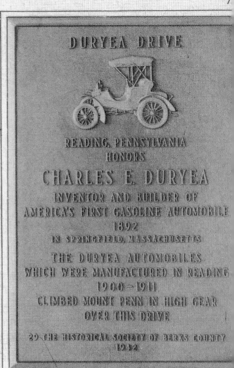

Reading, Penna., Where Duryea First Proved Automobiles Could Consistently Climb Mountain

CHARLES E. DURYEA. This card commemorates the Reading automotive achievements of adopted son Charles E. Duryea. On the reverse of the card are the words: "Charles E. Duryea in a *Duryea* (three cylinder) won first prize, Automobile Club of N.J., Eagle Rock Hill Climbing Contest, November 5, 1901. This was the first American hill-climb, regularly organized. A similar stock *Duryea*, freelance in the 1902 New York-Boston Run, ran around everything. Three cylinder Duryea cars were also manufactured in Coventry, England." (Berkshire News Company.)

Five

THE MOUNTAINS

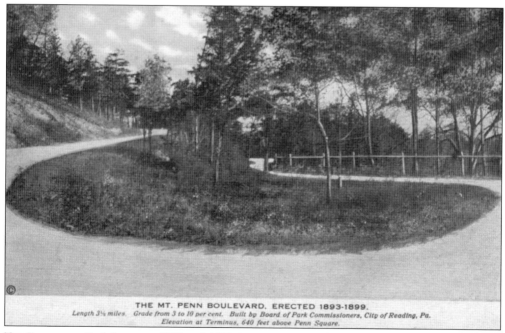

THE MT. PENN BOULEVARD, ERECTED 1893-1899.
Length 3¼ miles. Grade from 3 to 10 per cent. Built by Board of Park Commissioners, City of Reading, Pa.
Elevation at Terminus, 640 feet above Penn Square.

THE BOULEVARD. Built between 1893 and 1899, Mount Penn Boulevard twisted up the side of Mount Penn from Penn's Common (City Park). As noted on this card, the roadway reached an ultimate altitude of 640 feet above the city and did so on 3- to 10-percent grades. (H. Winslow Fegley.)

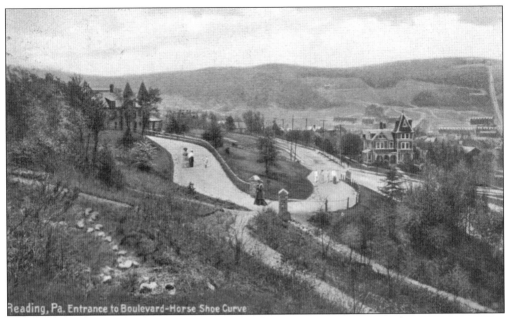

HORSESHOE CURVE. Although it follows the same general course as today's Duryea Drive, the Mount Penn Boulevard actually had many more twists and turns than at present. As seen in this picture looking toward Neversink Mountain, the boulevard was as much a promenade for strollers as a showcase for carriages. Mount Penn Boulevard was renamed Duryea Drive in 1942, honoring Charles E. Duryea, who tested hill-climbing automobiles on its roadway. (Hugh C. Leighton Company.)

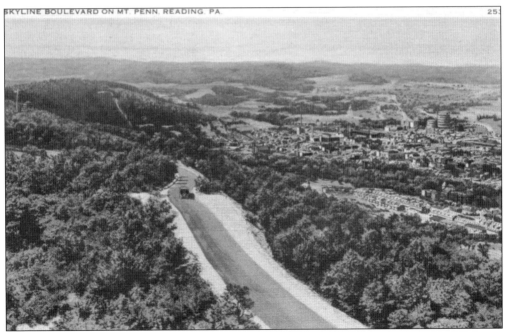

SKYLINE DRIVE. The Pagoda (far left), the Neversink Mountain "Incline Plane," and the old UGI gas tanks (upper right) are among the landmarks visible in this *c.* 1935 view. (Stichler & Company.)

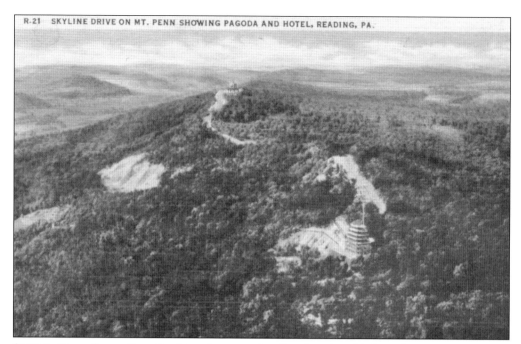

SKYLINE DRIVE, SCENE TWO. Looking the opposite direction (north) from the previous picture, this *c.* 1947 view extends from the Pagoda to the Tower Hotel at the summit of Mount Penn. Construction of the 4.5-mile-long Skyline Drive was begun in 1932 and completed in 1935. (Lynn H. Boyer Jr.)

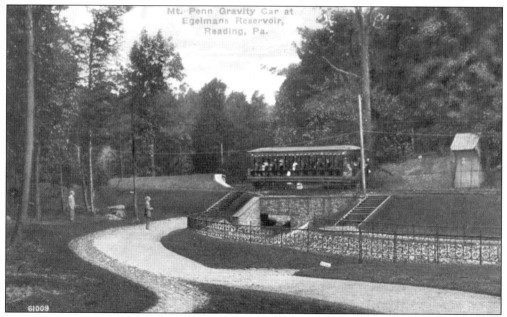

A GRAVITY RAILROAD CAR AT EGELMAN'S. While much has changed since this 1911 picture was taken, the old Gravity Railroad bridge at the dam at Egelman's Reservoir still exists today along Hill Road. (Souvo-Chrome.)

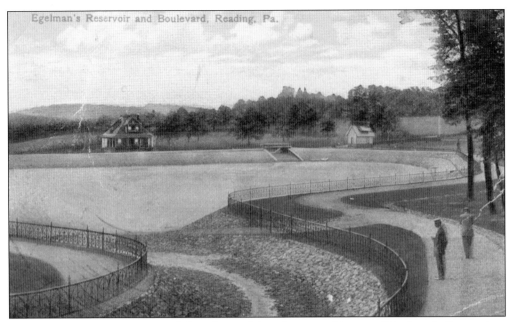

EGELMAN'S RESERVOIR. Again, much has changed, but the general layout of Egelman's Reservoir at Angora and Hill Roads remains the same as seen in this 1914 view. The reservoir was constructed in 1848 as a water supply for the city of Reading. (The Valentine-Souvenir Company.)

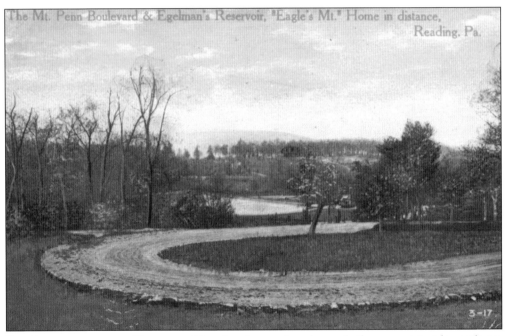

THE BOULEVARD AND THE RESERVOIR. Macadam has replaced gravel, the mountainside roadways have been slightly reconfigured, and the trees have grown to tall maturity since this 1920 view of Egelman's Reservoir from Mount Penn Boulevard (Duryea Drive) was captured on this card. (J. George Hintz.)

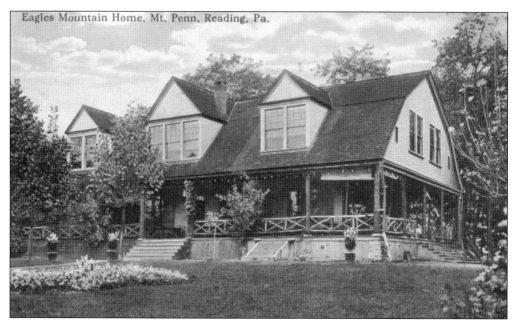

EAGLES' MOUNTAIN HOME. On Spook Lane just off Hill Road, the porches have been enclosed and some other modifications have been made, but the building is still there as the clubhouse of the Reading Liederkranz.

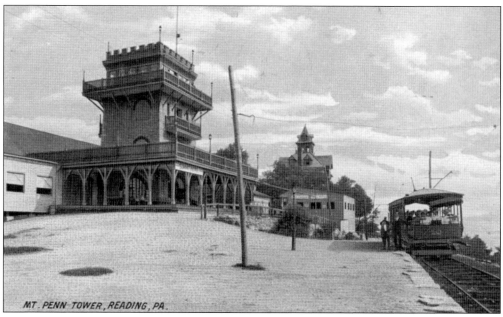

MOUNT PENN TOWER. The dance hall and concession stand are visible in this *c.* 1910 view of the former Mount Penn Tower and the Tower Hotel. The buildings were the ultimate destinations and the high point of the Mount Penn Gravity Railroad. One of the Gravity Railroad's cars is seen at the right. The tower depicted here went up in flames in spectacular fashion April 26, 1923.

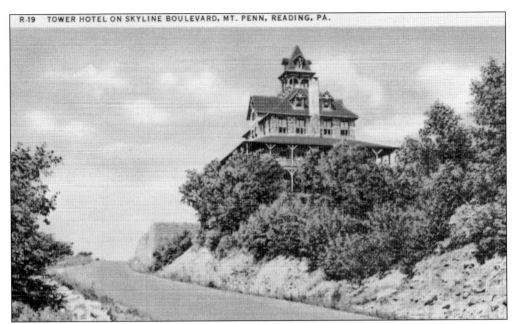

TOWER HOTEL. Actually, it was Schwartz's Summit House Hotel. Built in 1891 and renowned for its dances and other events, the hotel fell into disuse, ruin, and was demolished in the fall of 1959. Its foundations are still evident adjacent to the "the Fire Tower" atop Mount Penn. (Lynn H. Boyer.)

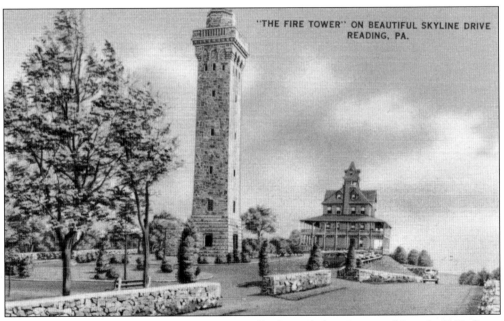

THE TOWER. Note the landscaped, intact stone walls along Skyline Drive in this early 1950s linen postcard view. The Tower, officially the William Penn Memorial Tower, was dedicated October 28, 1939, and still stands on the highest point of Mount Penn. One-hundred-twenty steps led to the top of the tower, which served originally as a forest fire observation tower. The Summit House Hotel to the right was demolished in 1959. (Colourpicture Publications.)

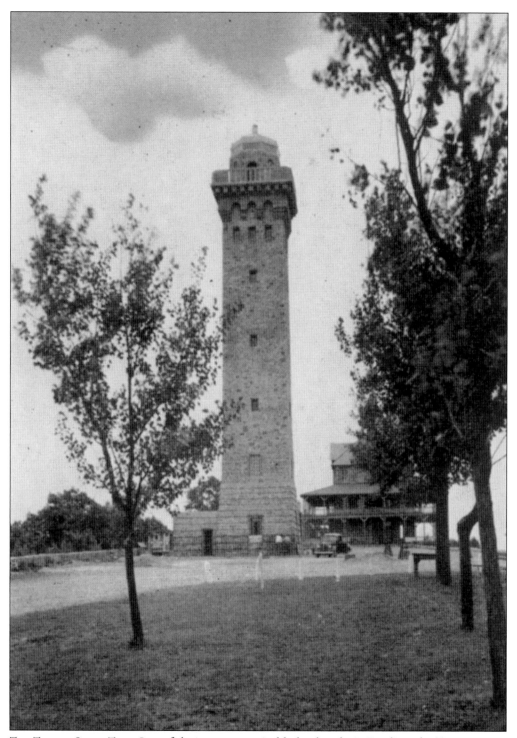

THE TOWER, SCENE TWO. One of the most recognizable landmarks in Reading, the Tower is seen in this more realistic photograph. As this book was being compiled, a sweeping effort to restore and reopen the building was underway. (Dexter Press.)

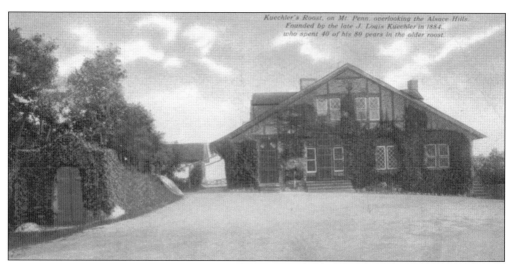

Kuechler's Roost, on Mt. Penn, overlooking the Alsace Hills. Founded by the late J. Louis Kuechler in 1884, who spent 40 of his 80 years in the older roost.

KUECHLER'S ROOST. Known to historians as "the New Roost," this chalet-style structure replaced an earlier structure built in the woods of Mount Penn by Jacob Louis Kuechler. In 1882, Kuechler gave up the life he had known and lived a hermit's life in a crude frame building that stood where this building was later built. Folks would visit Kuechler's roost to partake of the products of his vineyard and converse about issues of the day. Actually, Kuechler never saw this version of his roost, as it was built in 1907, after his death. A new clientele of Reading's intellectual and interesting gathered in the New Roost, and the ornately carved table around which they sat is now housed at the Historical Society of Berks County. (H. Winslow Fegley.)

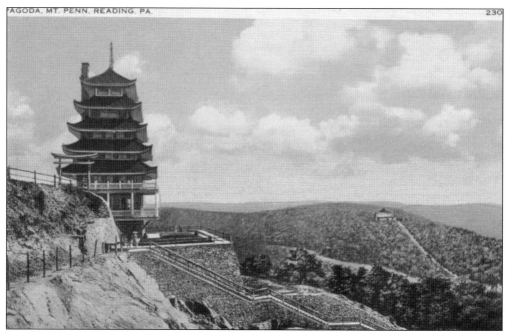

THE PAGODA. For good measure, a view of the Highland House hotel across the way on Neversink Mountain is included. What is interesting about this view of the Pagoda is the lower roadway to the left (marked by posts). It is what remains of the right-of-way of a short spur of the Mount Penn Gravity Railroad used to shuttle building supplies into the Pagoda site. (Stichler & Company.)

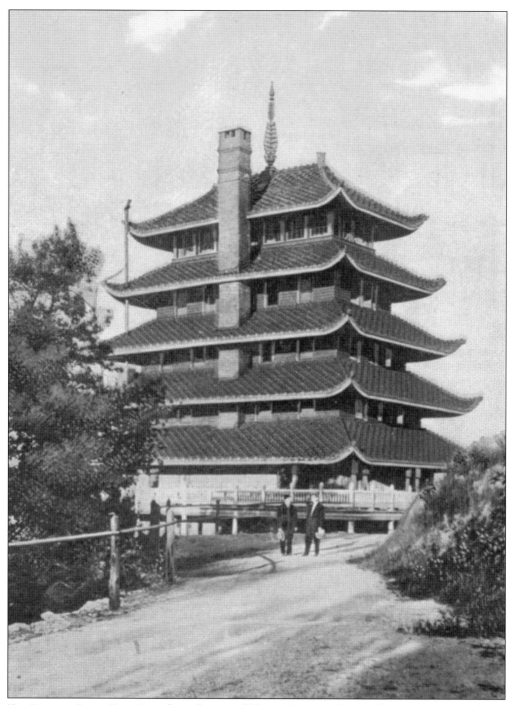

THE PAGODA, SCENE TWO. Seen from the top of Mount Penn Boulevard (Duryea Drive), Reading's landmark building was designed by its private builder to be a hotel. It was not granted a liquor license, however, owing to the dangerous roads that led to and from it. Thus, the building was turned over to the city in 1911 and has remained under its wing ever since. Citizen involvement in later years resulted in its restoration and reuse as a community center and gallery.

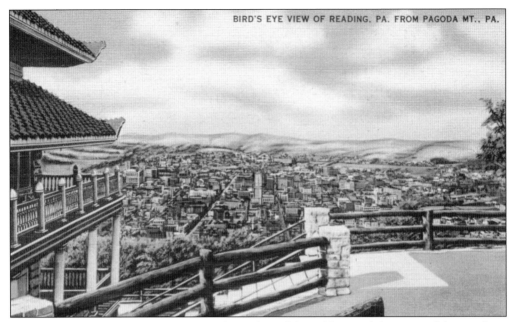

THE PAGODA, SCENE THREE. The growth of trees has all but obliterated this view of the city from the north side of the Pagoda, but this 1950s linen card was one of the most popular ever mailed by tourists out of Reading to friends back home. (Berkshire News Company.)

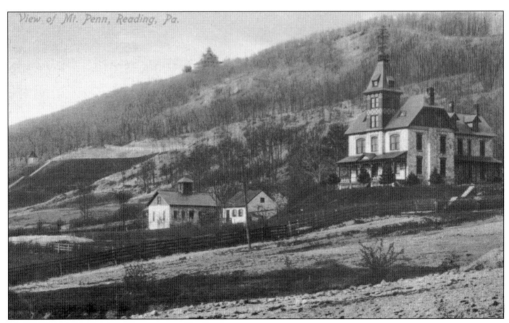

A VIEW OF MOUNT PENN. The Summit House hotel rises high on top of the mountain as seen from the Wanner Mansion at the head of Walnut Street. The old mansion still exists as an apartment building, and the city has since grown up to its front door.

A GRAVITY RAILROAD STATION. This station once stood near the present tennis courts under the Lindbergh Viaduct between Pendora and Mineral Springs Parks. The station opened in 1890 and was the point of origin of trips to the summit of Mount Penn (tugged by a steam engine) and back down again (by gravity). The concrete slab that was part of this station platform still exists under the viaduct. (A.C. Bosselman & Company.)

ALONG THE GRAVITY RAILROAD. The Mount Penn Gravity Railroad once carried passengers 2.5 miles from Pendora Park to the Summit Hotel atop Mount Penn, and then 5 miles down the east side of the mountain via gravity to the starting point. Financial problems and two fatal accidents spelled doom for the once popular attraction, but remnants of its right-of-way are still visible atop the mountain. (Hugh C. Leighton.)

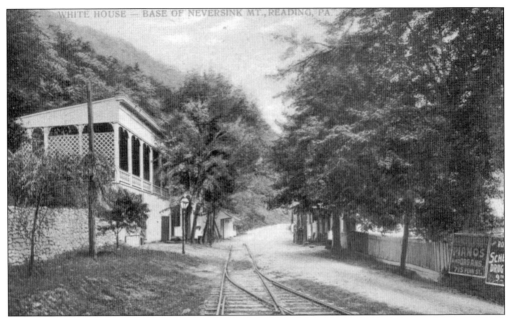

THE WHITE HOUSE. Located on South Ninth Street south of the Reading Brewery, the White House Hotel was a popular spot for locals and visitors. Among its most notable guests was boxing legend John L. Sullivan. The hotel (behind the trees to the right in this picture) stood at the foot of the Neversink Mountain Railroad, which chugged up and around Neversink Mountain. Also pictured here is the old White House Natural Spring Water bottling plant. (A.C. Bosselman & Company.)

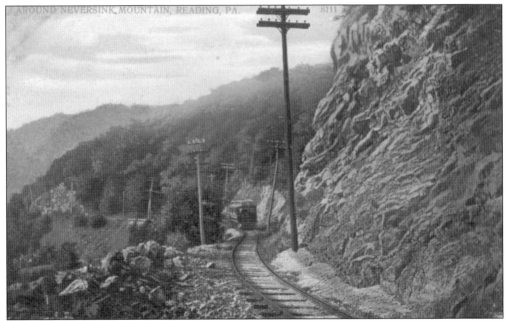

AROUND NEVERSINK MOUNTAIN. The Neversink Mountain Railroad took passengers from the city around the mountain on a 7-mile route to attractions at Klapperthal (near the present Forest Hills Memorial Park) and other spots. The line opened in the summer of 1890 and closed in 1917. (A.C. Bosselman & Company.)

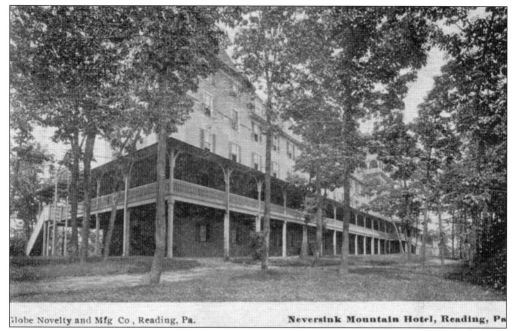

NEVERSINK MOUNTAIN HOTEL. Completed in June 1892, this 14-acre resort stood at the head of South Twenty-third Street, where a radio broadcasting tower now stands. Five stories tall, with 166 rooms, the hotel was never financially successful, and succumbed to a spectacular fire on September 29, 1905. (Globe Novelty.)

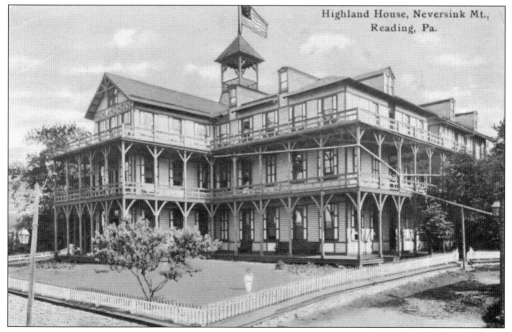

THE HIGHLAND HOUSE. The second of the resort hotels on Neversink Mountain, this hotel looked over the city from the top of the Incline Plane near South Thirteenth Street. Opened in 1884 on an 80-acre tract, the 118-room hotel burned in October 1930. (W. Charles Lewars.)

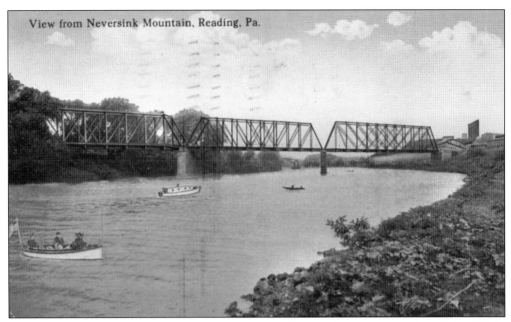

View from Neversink Mountain, Reading, Pa.

THE SCHUYLKILL RIVER FROM NEVERSINK MOUNTAIN. Rowboats ply the waters of the Schuylkill in this view, taken *c.* 1916. The bridge is the old Spruce Street Railroad Bridge, which collapsed into the river in the 1960s.

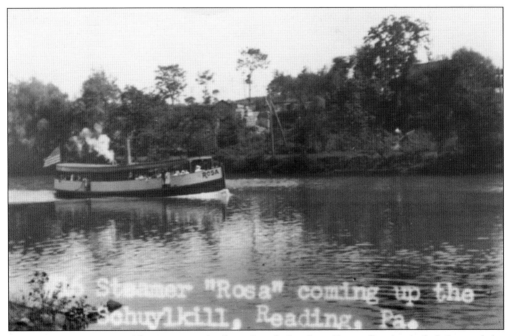

"ROLLIN' ON THE RIVER." The *Rosa* was built in Conshohocken, Pennsylvania, and christened the *Martha Washington.* The 65-foot boat was purchased by John Hiester and moved to Reading to serve along with her sister boat, the *Carrie*, as steam passenger excursion boats on the river. It was said that each of the vessels, which last sailed in 1917 (when the river became choked with coal silt), could carry 500 passengers. (Real photo postcard, unattributed.)

Six

AMUSEMENT AND ENTERTAINMENT

THE CIRCUS MAXIMUS. This circus ground stadium once stood on the grounds of the present Shirk Stadium at Albright College in northeast Reading. (Real photo postcard, unattributed.)

THE TURN-VEREIN GYM. On the southwest corner of Fifth and Franklin Streets, this was also the Independent Order of Odd Fellows Hall. As a community auditorium, it hosted many quality theatrical presentations, including an appearance by Gen. Tom Thumb and his bride. Built in 1846, the building was structurally unsound by 1911 and was demolished. The main Reading Public Library building stands on the site. (Real photo postcard, unattributed.)

THE COLLEGE HEIGHTS DRIVING RANGE. Situated along the Pricetown Road on the site of a former NYA Camp, this driving range and miniature golf course was located near the present Reading-Muhlenberg Vocational Tech School. (Berkshire News Incorporated.)

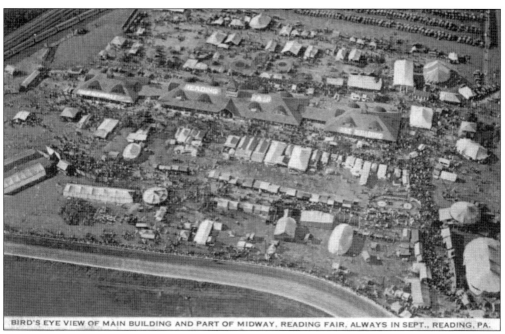

BIRD'S EYE VIEW OF MAIN BUILDING AND PART OF MIDWAY. READING FAIR, ALWAYS IN SEPT., READING, PA.

THE READING FAIRGROUNDS. This aerial view of the old fairgrounds shows a portion of the backstretch of the Reading Fairgrounds Speedway, the Midway (left), and exhibition buildings. The fairgrounds were opened in 1915, closed in 1979, and were replaced by the Fairgrounds Square Mall. (William B. Nichols.)

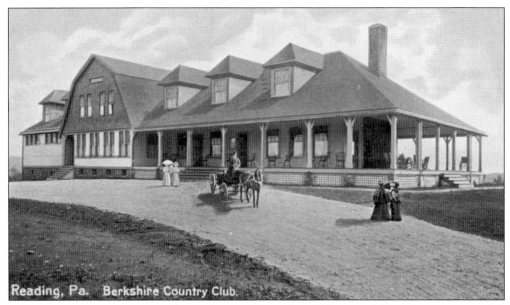

THE BERKSHIRE COUNTRY CLUB. This early view shows the clubhouse of the elegant country club and golf course located along Route 183. (Hugh C. Leighton Company.)

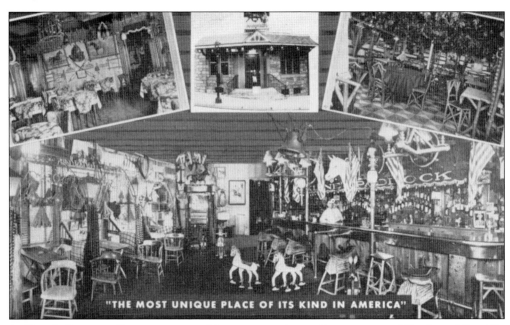

AL KLINE'S PADDOCK. For many years, this tavern on the southeast corner of Tenth and Franklin Streets served customers in a most unique atmosphere. Albert Kline was an avid horseman, trainer, and harness racer. When he retired from the track in 1937, he opened a bar and outfitted it floor to ceiling with equestrian equipment and racing memorabilia. Patrons could race on the floor riding miniature wheeled horses, belly up to the bar and sit on saddles, and enjoy a dinner on tables crafted from wagon wheels. A fire in an upper-story room gutted much of the building in 1994. However, much of the interior appointments in the bar and restaurant were only slightly damaged, salvaged, and sold to collectors. The Paddock was gone forever, though.

Seven

Transportation

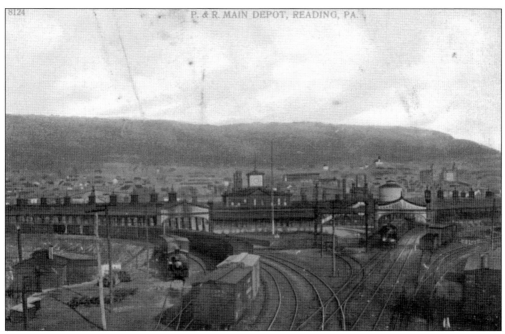

THE OUTER STATION. Once the center of activity for the Philadelphia & Reading Railroad in Reading, the Outer Station along North Sixth Street opened in 1874. It closed in March 1969 and was severely damaged in a fire in February 1978. Two months later, it was razed. (A.C. Bosselman & Company.)

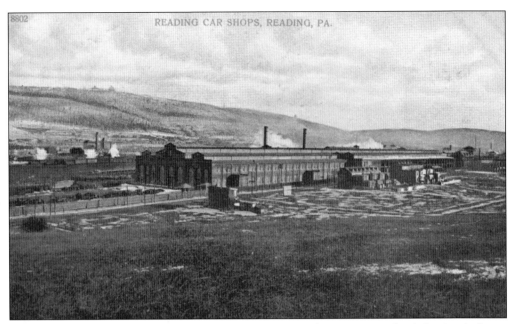

READING CAR SHOPS. At one time, these car and locomotive shops were Reading's busiest industry and biggest employer. Many of the massive structures still stand forlornly along North Sixth Street in the city. (A.C. Bosselman & Company.)

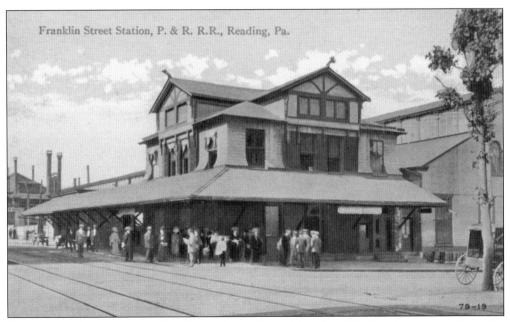

THE FRANKLIN STREET STATION. This first station at Seventh and Franklin Streets was actually on the corner of those two streets. It opened in 1884 to serve downtown rail passengers. It was replaced in 1930 when the new Franklin Street Station was built and opened next door. This station was quickly removed when the new station opened. (The Post Card Distributing Company.)

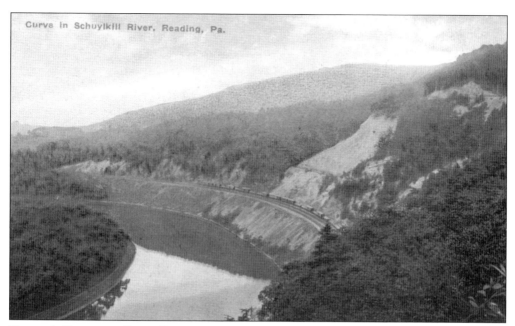

Curve in Schuylkill River, Reading, Pa.

READING'S HORSESHOE CURVE. From a vantage point atop Neversink Mountain, the graceful curve of the Philadelphia & Reading Railroad tracks can be seen on the edge of the mountain along the Schuylkill River.

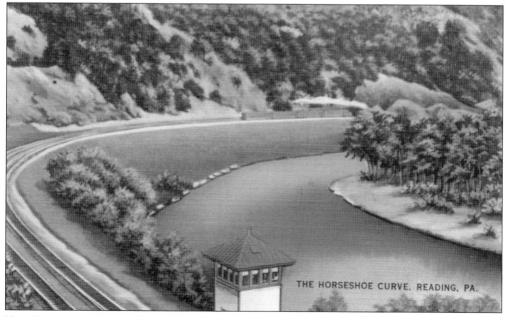

THE HORSESHOE CURVE. READING, PA.

THE HORSESHOE CURVE, SCENE TWO. In a bit more stylized linen postcard, this view of the horseshoe curve is from beneath Neversink Mountain, *c.* 1950. (Berkshire News Company.)

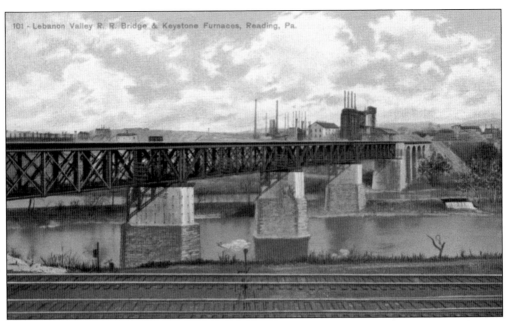

THE LEBANON VALLEY RAILROAD BRIDGE. The first bridge across the Schuylkill River at this site was burned during the Railroad Riots of 1877 and replaced by this span. The pillars of the older bridge are still visible adjacent to this bridge. Also visible in this picture are the Keystone Furnaces in Reading and Giles' Lock of the Schuylkill Canal. (J. George Hintz.)

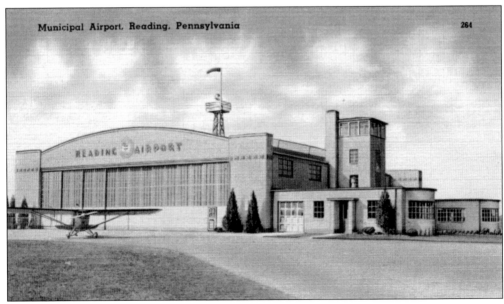

Municipal Airport, Reading, Pennsylvania 264

THE MUNICIPAL AIRPORT. This former hanger-terminal-control tower complex (*c.* 1945) was to become the Gen. Carl A. Spaatz Field–Reading Regional Airport. The building still stands, but is in private hands on airport grounds. (Stichler & Company.)

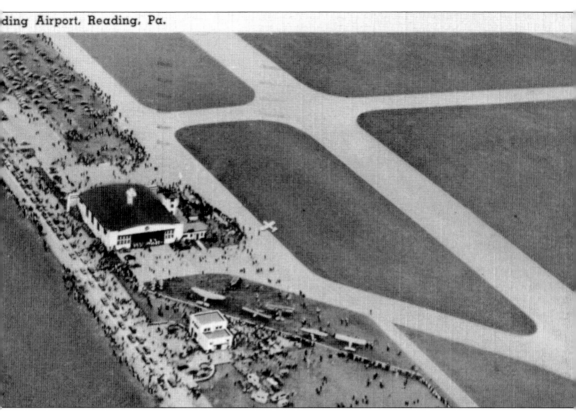

THE MUNICIPAL AIRPORT, SCENE TWO. The terminal building seen in the previous photograph is the centerpiece of this aerial view. Also note the smaller building to the south—now the Greenfields Fire Company building. (Berkshire News Company.)

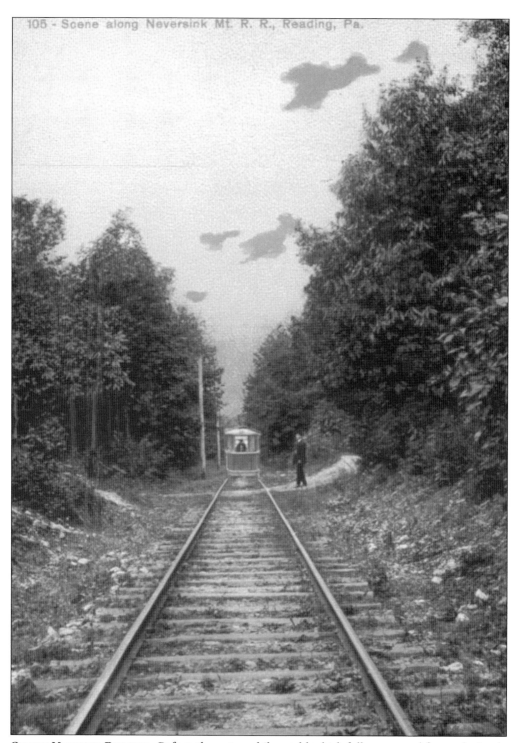

ON THE MOUNTAIN RAILROAD. Before the automobile could whisk folks near and far, such simple pleasures as a ride on the Neversink Mountain Railroad or a stroll along its right-of-way provided simple pleasures. (J. George Hintz.)

Eight

THE BRIDGES

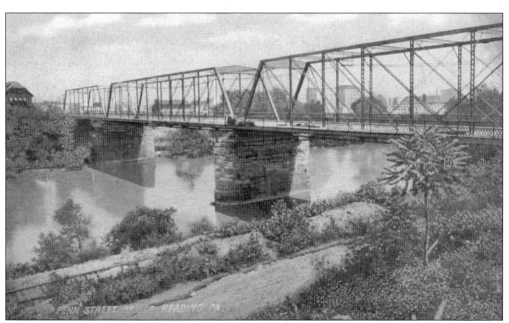

THE OLD PENN STREET BRIDGE. This iron bridge connecting Reading and West Reading was built in 1884 and replaced when the present Penn Street Bridge was opened in 1914. A portion of the Pennsylvania Railroad station can be seen at the far left.

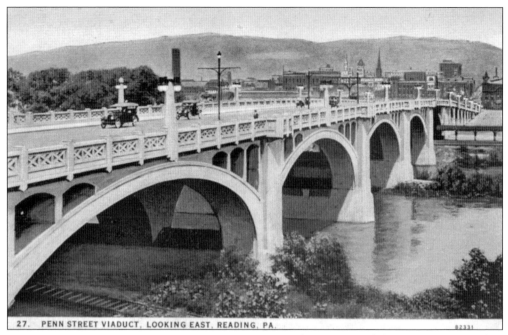

27. PENN STREET VIADUCT, LOOKING EAST, READING, PA.

THE PENN STREET BRIDGE. It is interesting to compare this picture of the Penn Street Bridge, looking toward the city, with the next view. Note the differences in the city skyline.

PENN STREET BRIDGE, READING, PA.

THE PENN STREET BRIDGE, SCENE TWO. This *c.* 1942 view incorporates the same eastbound view as the previous image, but includes the Metropolitan Edison Building, the Hotel Abraham Lincoln, and the Berks County Courthouse in the city's growing skyline. (Berkshire News Company.)

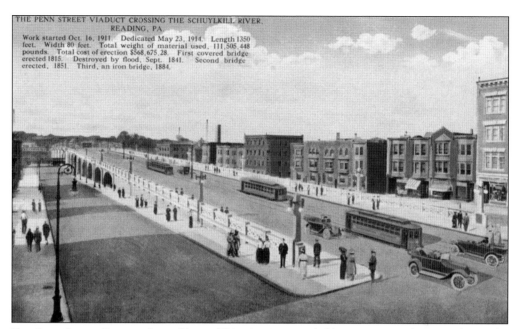

THE PENN STREET BRIDGE, SCENE THREE. This view is remarkable to anyone who never knew the former lay of the land on the Reading side of the Penn Street Bridge. All the structures on this picture were demolished to make way for a hotel (now Reading Area Community College) on the left and a parking lot on the right. (H. Winslow Fegley.)

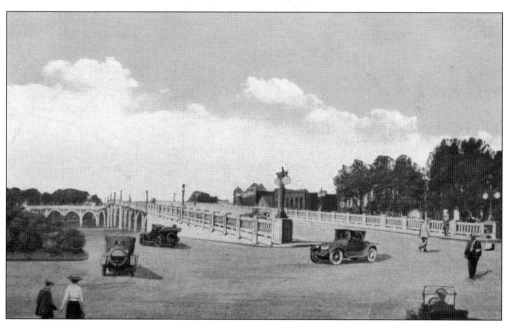

THE BINGAMAN STREET BRIDGE. The city side of the bridge (actually, both sides are in the city of Reading) was quite different in this c. 1922 depiction of the span. The bridge cost a whopping $800,000 to build between 1920 and 1921, and replaced an iron bridge that connected Lancaster Avenue and Bingaman Street. The concrete bridge was dedicated on December 3, 1921. (Stichler & Company.)

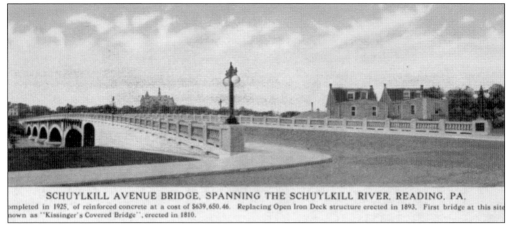

SCHUYLKILL AVENUE BRIDGE, SPANNING THE SCHUYLKILL RIVER, READING, PA.
Completed in 1925, of reinforced concrete at a cost of $639,650.46. Replacing Open Iron Deck structure erected in 1893. First bridge at this site known as "Kissinger's Covered Bridge", erected in 1810.

THE SCHUYLKILL AVENUE BRIDGE. Looking north, this view of the bridge that still exists includes a glimpse of the House of Good Shepherd in the distance. Note that the cost of this span, dedicated in 1925, was $639,650.46. (H. Winslow Fegley.)

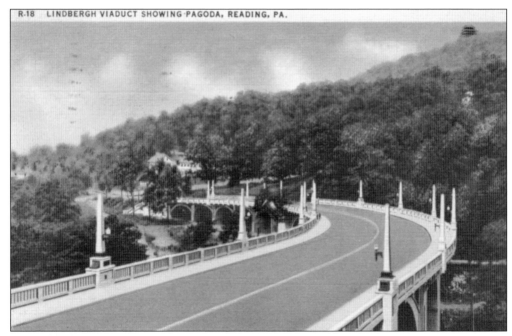

R-18 LINDBERGH VIADUCT SHOWING PAGODA, READING, PA.

THE LINDBERGH VIADUCT, SCENE TWO. Note the Pagoda atop Mount Penn in the upper right corner of this view of the viaduct as it curves into the city. It was said that the curve (now considered quite impractical and dangerous) was added to the design of the viaduct to provide a graceful entrance into the city from Mount Penn borough. The viaduct, named after aviation hero Charles Lindbergh, spans a tiny creek (Rose Creek) and divides Pendora (to the left in this picture) and Mineral Spring parks. (Lynn H. Boyer.)

86

Nine

GENERAL VIEWS

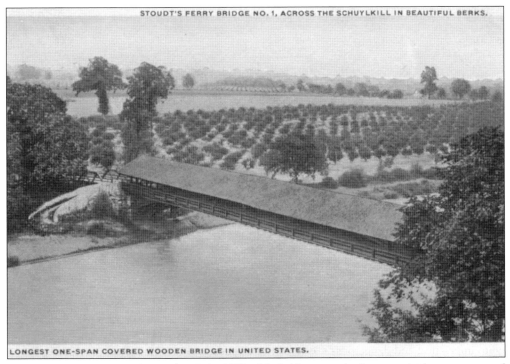

STOUDT'S FERRY BRIDGE NO. 1, ACROSS THE SCHUYLKILL IN BEAUTIFUL BERKS.

LONGEST ONE-SPAN COVERED WOODEN BRIDGE IN UNITED STATES.

STOUDT'S FERRY BRIDGE. Opened in July 1857, this bridge was the longest single-span covered bridge (225 feet long, 19 feet above the Schuylkill River) in the world. It gradually fell into disrepair and collapsed on September 10, 1948. (H. Winslow Fegley.)

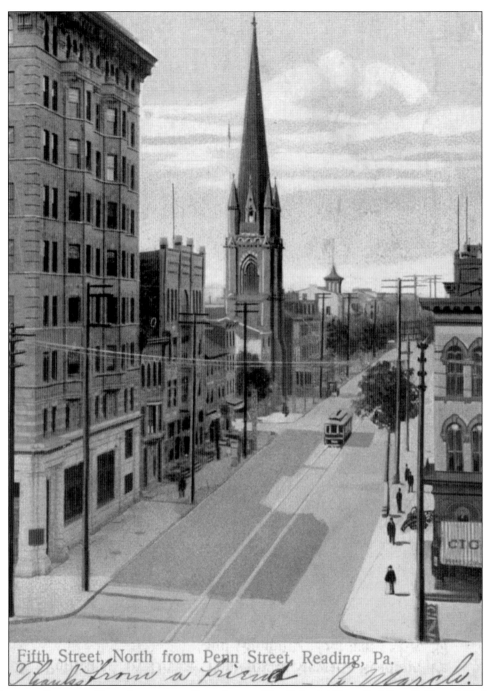

Fifth Street, North from Penn Street, Reading, Pa.

LOOKING NORTH ON FIFTH STREET FROM PENN STREET. The Colonial Trust Building (left) and Christ Episcopal Church dominate this scene from *c.* 1907. Also note the tall building between the bank and church—the former Reading Herald offices. When the bank expanded and demolished that and other buildings on that side of the street, it craftily dismantled the facade of the old newspaper office building and had it reinstalled on a nondescript building in the 400 block of Penn Street, where it still stands. (Dives, Pomeroy, & Stewart.)

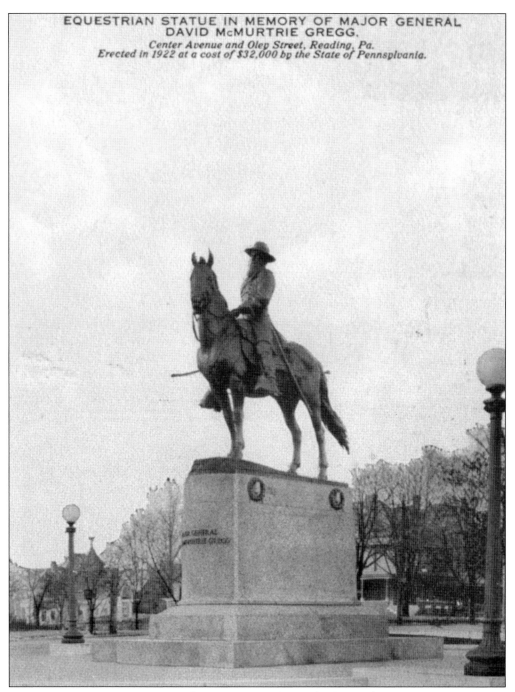

EQUESTRIAN STATUE IN MEMORY OF MAJOR GENERAL
DAVID McMURTRIE GREGG.
Center Avenue and Oley Street, Reading, Pa.
Erected in 1922 at a cost of $32,000 by the State of Pennsylvania.

THE GREGG EQUESTRIAN STATUE. Still standing proudly in the heart of the Centre Park Historic District at Centre Avenue and Oley Street, this statue by sculptor Augustus Lukeman was unveiled on July 7, 1922. It honors Civil War hero Maj. Gen. David McMurtrie Gregg. General Gregg, who also served as Pennsylvania auditor general from 1892 to 1894, was a native of Huntington, Pennsylvania. He resided in Reading from 1874 until his death in his 106 North Fourth Street home on August 7, 1916. (H. Winslow Fegley.)

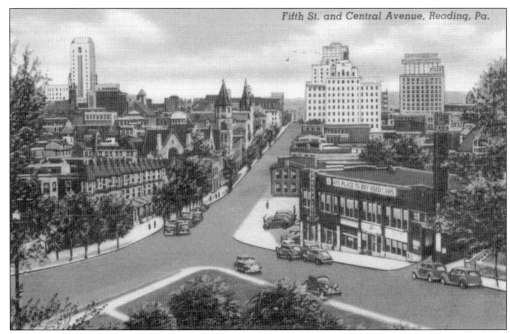

FIFTH STREET AND CENTRE AVENUE. A major intersection in the center of the city, this was once not a corner at all. At one time, North Fifth Street ended here, and traffic was routed onto what is now Centre Avenue. A crude landfill that stood where Fifth Street veers off to the left in this view was filled in, and the upper end of Fifth Street was connected to the lower. The large auto dealership building to the right in this picture is now the site of a fast-food restaurant. (Berkshire News Company.)

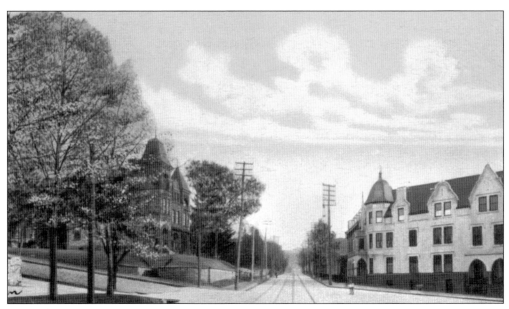

PERKIOMEN AVENUE FROM CITY PARK. Note the turtle fountain at the edge of the park on the left and the former Kreitz Mansion in the trees—now the site of the Kesher Zion synagogue. (Souvenir Post Card Company.)

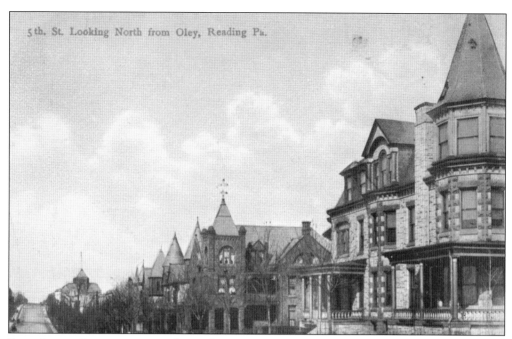

FIFTH STREET, LOOKING NORTH. Elegant homes and apartment buildings still grace this section of the city, and almost all of these structures still stand among taller trees and a busier street. (A.C. Bosselman & Company.)

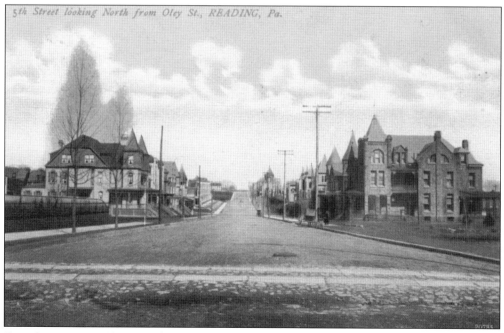

FIFTH STREET, SCENE TWO. Another angle takes in a more sweeping view of North Fifth Street from Oley Street. (Souvenir Post Card Company.)

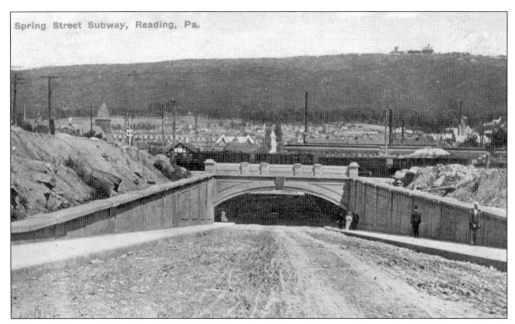

THE SPRING STREET SUBWAY. Still extant, still flooding on occasion, the Spring Street Subway carries traffic under the railroad tracks in the center of the city. And yes, it has since been paved since its construction in 1908–1909. Note the tower and hotel atop Mount Penn.

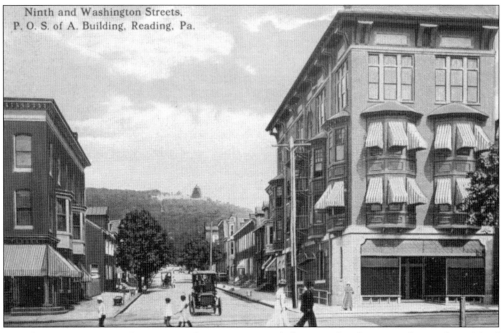

NINTH AND WASHINGTON STREETS. Looking east toward the Pagoda, this view shows the POS of A Building on the right, better known to generations of Readingites as the home of Richards Music Store.

92

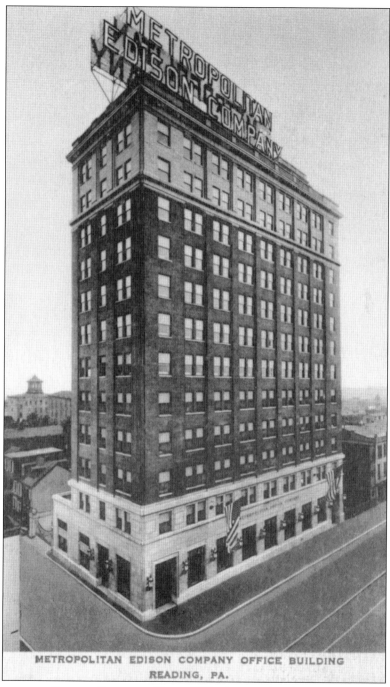

METROPOLITAN EDISON COMPANY OFFICE BUILDING
READING, PA.

THE METROPOLITAN EDISON COMPANY. Now GPU, the area's electric company was once headquartered in this towering building in the 400 block of Washington Street downtown. It is now an office building called the Madison. The reverse of this card reads, "Site of this office building was occupied from 1765 to 1868 by Society of Friends one-story log meetinghouse, used by women of Reading during Revolutionary War as hospital for wounded soldiers." (Associated Gas & Electric System.)

93

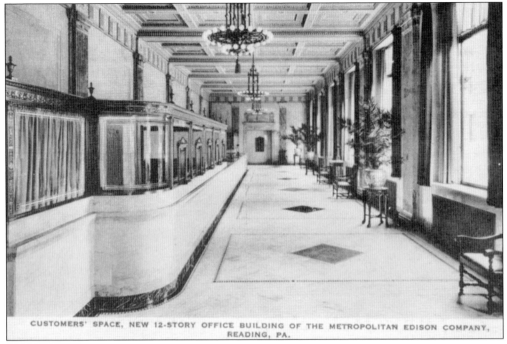

CUSTOMERS' SPACE, NEW 12-STORY OFFICE BUILDING OF THE METROPOLITAN EDISON COMPANY, READING, PA.

THE INTERIOR OF THE METROPOLITAN EDISON COMPANY BUILDING. Once the customer service center for the city's electric company, this impressive lobby was more recently a bank branch office.

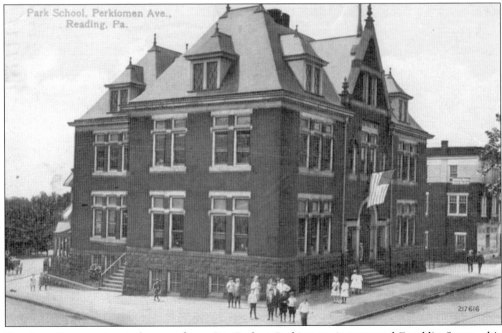

Park School, Perkiomen Ave., Reading, Pa.

THE PARK SCHOOL. Located across from City Park at Perkiomen Avenue and Franklin Street, this school was in existence for a comparatively short time. A drug store now occupies the site. (The Valentine-Souvenir Company.)

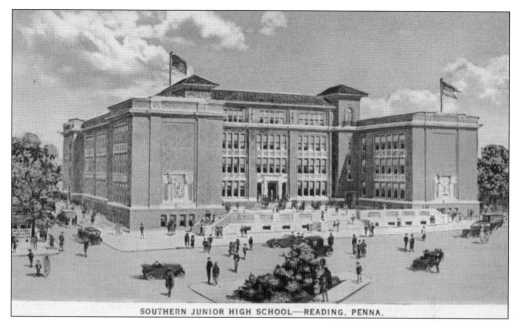

SOUTHERN JUNIOR HIGH SCHOOL. Now the Southern Middle School, this structure at Tenth and Chestnut Streets was opened in 1926. The total cost of its construction was $1.1 million. It was built on the site of the former Deppen Brewery.

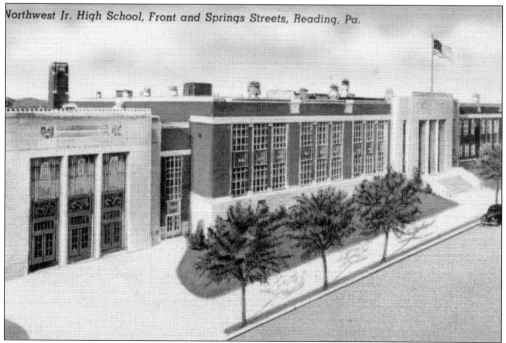

NORTHWEST JUNIOR HIGH SCHOOL. Located at Front and Spring Streets, the gymnasium of this school was once the home court of Reading High School basketball teams before the Geigle Complex was built at Reading High. (Berkshire News Company.)

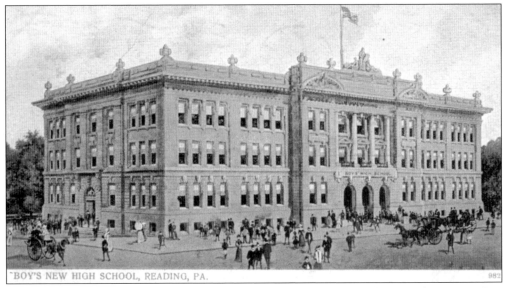

"BOY'S NEW HIGH SCHOOL, READING, PA. 982

THE BOYS' HIGH SCHOOL. This building served as a high school for boys from 1906 to 1927, when the girls' and boys' schools were unified into the "Castle on the Hill," or Reading High School, at Thirteenth and Douglass Streets. (A.C. Bosselman & Company.)

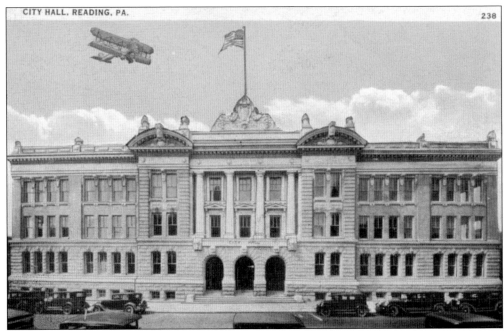

CITY HALL, READING, PA. 238

THE CITY HALL. Does this building look familiar? After the Boys' High School closed, the building became—and remains—Reading's city hall. (Stichler & Company.)

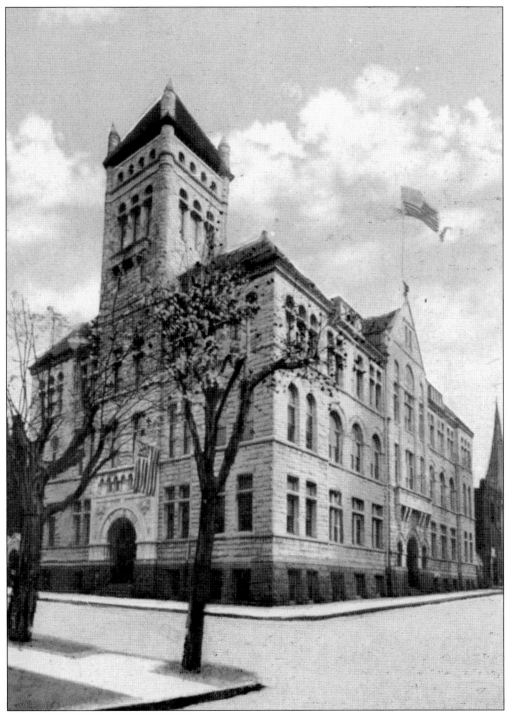

THE GIRLS' HIGH SCHOOL. Located at Fourth and Court Streets, this school also closed in 1927 when Reading High School opened. Before it was demolished, the facility served as Southwest Junior High School and later a special education center. The building was torn down in 1961. Today, a parking lot for the Madison occupies the site. (The Acmegraph Company.)

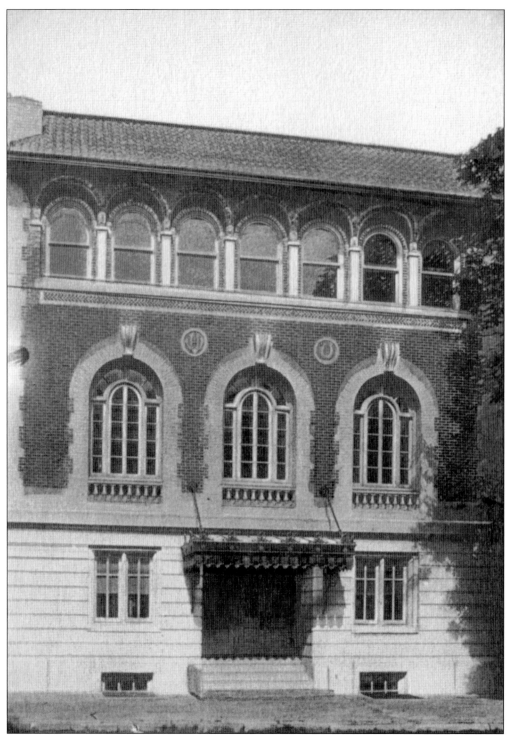

HARMONIE MAENNERCHOR. Organized by German-speaking citizens of Reading in 1847, this society moved into Maennerchor Hall in 1874. The building still stands on North Sixth Street between Washington and Walnut. At the time this book was compiled, it housed law offices.

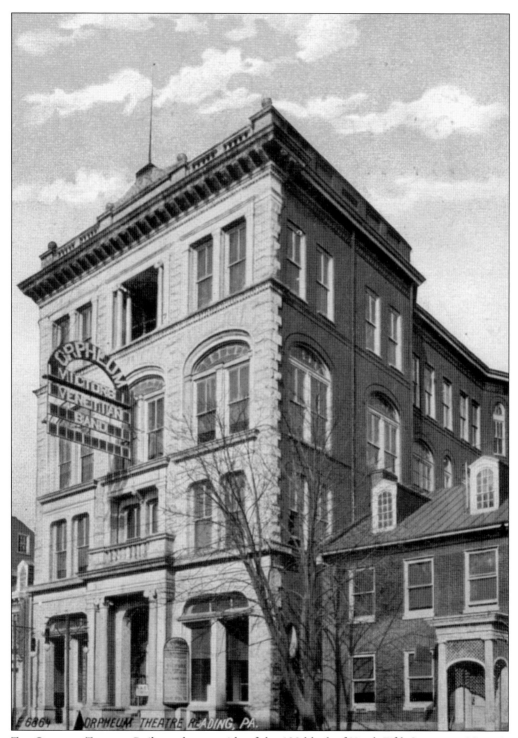

THE ORPHEUM THEATRE. Built on the east side of the 100 block of North Fifth Street as a Masonic Temple in 1898, the first public theater opened as the Temple Theatre in 1902. It was renamed the Orpheum Theatre in 1905 and then the Plaza in 1946. A parking lot now occupies the site.

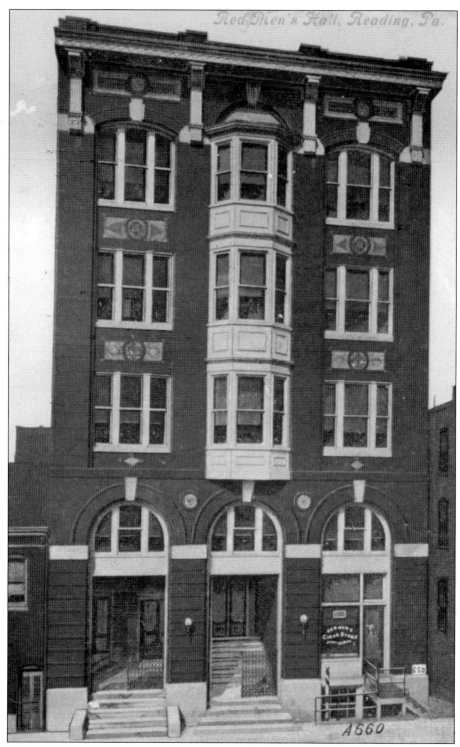

RED MEN'S HALL. This club headquarters stands at 831 Walnut Street and was the site of the Family Movie Theatre at one time. Later, the Police Athletic League occupied the building.

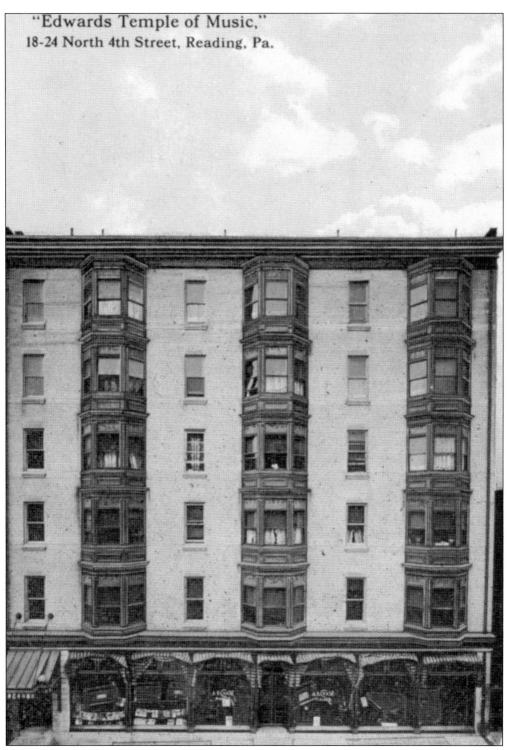

EDWARDS' TEMPLE OF MUSIC. This structure still stands, basically intact, on the east side of the first block of North Fourth Street. (Leo Meyer.)

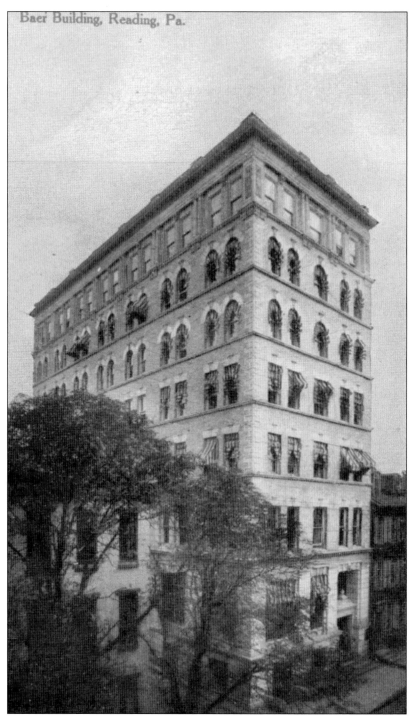

Baer Building, Reading, Pa.

THE BAER BUILDING. Developed by George F. Baer on the northeast corner of Church and Court Streets, this building, completed in 1900, was one of the city's tallest structures at the time. The Reading Iron Company once occupied two floors of office space there. Its early promotional material boasted that it was "constructed along the most approved lines of sanitation and ventilation."

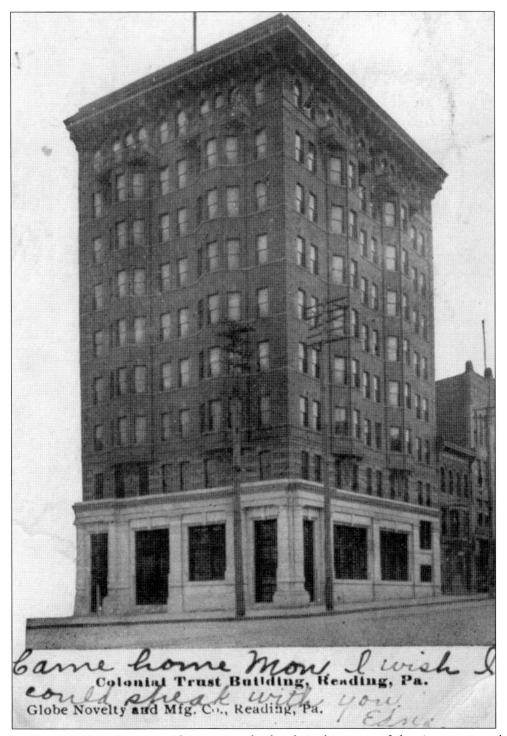

Came home Now I wish I could speak with you.
Elsie

Colonial Trust Building, Reading, Pa.

Globe Novelty and Mfg. Co., Reading, Pa.

THE COLONIAL TRUST BUILDING. This ten-story landmark in the center of the city was erected in 1903. Today, the building houses bank offices. Its lobby contains magnificent architectural appointments, murals, and artwork.

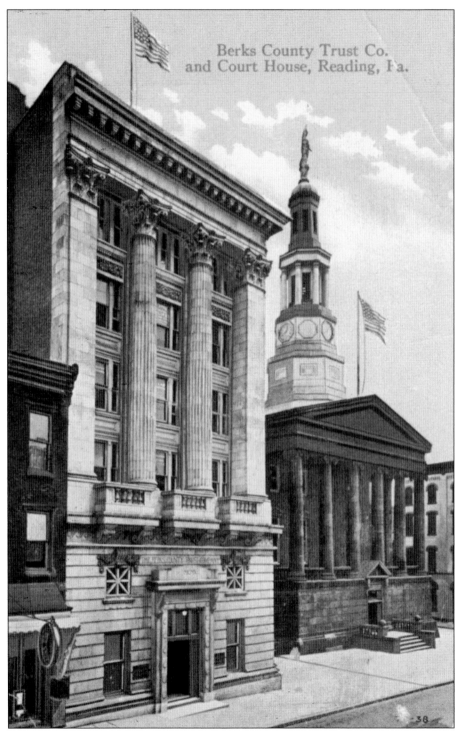

THE BERKS COUNTY TRUST COMPANY AND THE BERKS COUNTY COURTHOUSE. Of the buildings in this view, only the bank building (still a bank building) remains. The courthouse pictured was replaced by the present structure, which was built in 1932. (The Post Card Distributing Company.)

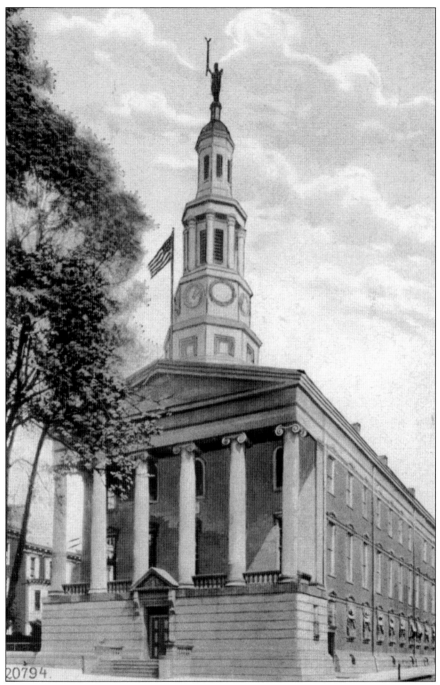

THE BERKS COUNTY COURTHOUSE. Seen in this *c.* 1915 picture, the old county courthouse stood on the site of the present county building. Built in 1840, its steeple rose 146 feet. A wooden statue, *Goddess of Liberty*, was placed on its peak, but was later replaced by a hollow copper replica because of the overbearing weight of the wooden piece. This building was designed by Thomas U. Walter, who also designed the expansion of the U.S. Capitol. (Souvenir Post Card Company.)

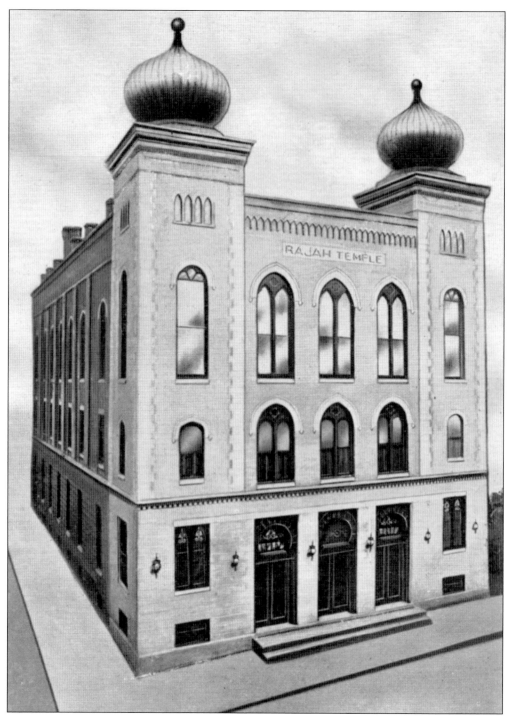

THE RAJAH TEMPLE. This early (built in 1913) Rajah Temple building still stands (minus the onion-shaped domes) at Franklin and Pearl Streets. It was built on the site of the former St. Matthew's Church. It was in this building on January 27, 1913, that the predecessor of today's Berks County Chamber of Commerce was formed.

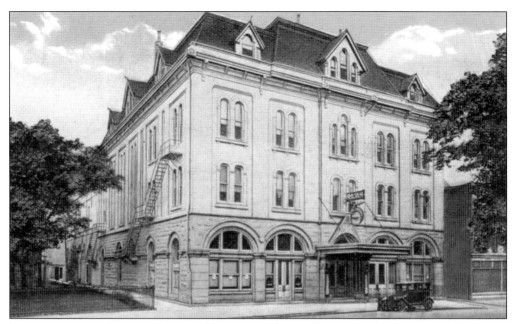

THE SECOND RAJAH TEMPLE. The second location of the Rajah Temple and Theatre was the former Academy of Music building on North Sixth Street. The building was purchased by the shrine in 1917 and included a 1,500-seat theater. After a gala social event there on May 21, 1921, fire ripped through the building and destroyed it. (Sabold-Herb Company.)

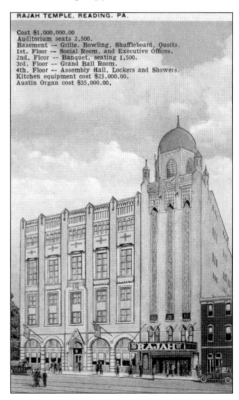

THE THIRD RAJAH TEMPLE. Eighteen months after the fire that gutted the former building, this temple and theater was built. In a slightly modified form, this is the present Rajah Theatre, long a focal point of entertainment in Reading. Note the construction details on the face of the card. (Stichler & Company.)

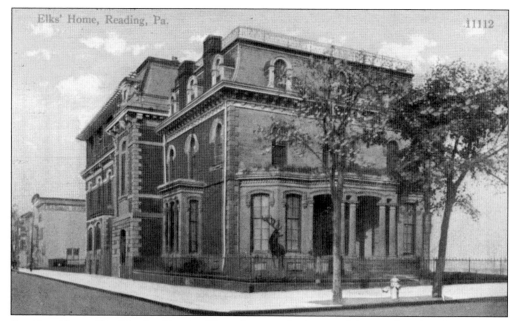

THE ELKS HOME. The "Trexler Mansion" later became the home of the Loyal Order of Elks. At the time this book was being compiled, it was destined to be restored for community use. (The Post Card Distributing Company.)

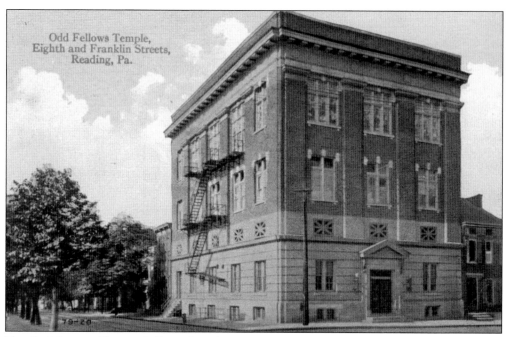

THE ODD FELLOWS TEMPLE. Still standing, but ravaged by time and neglect, this structure, known for its now missing stained-glass windows, has most recently served as a night club of sorts and an apartment building. (The Post Card Distributing Company.)

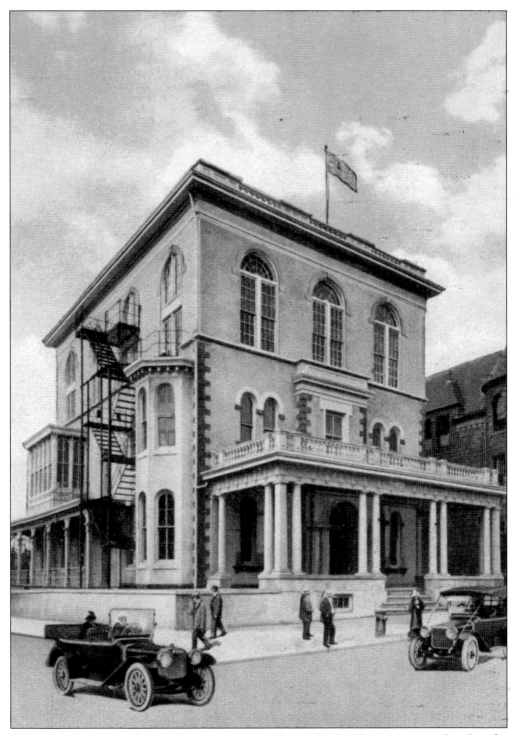

THE KNIGHTS OF MALTA TEMPLE. Once a private residence, this building was a popular place for meetings and presentations. It stood on the northwest corner of Fourth and Court Streets, where the WEEU radio studios and offices now stand.

THE WOMAN'S CLUB HEADQUARTERS. Originally the Wyomissing Club before that organization moved to larger quarters, this structure was purchased by the Woman's Club in 1919 and still serves as the home of the Woman's Club of Reading. (H. Winslow Fegley.)

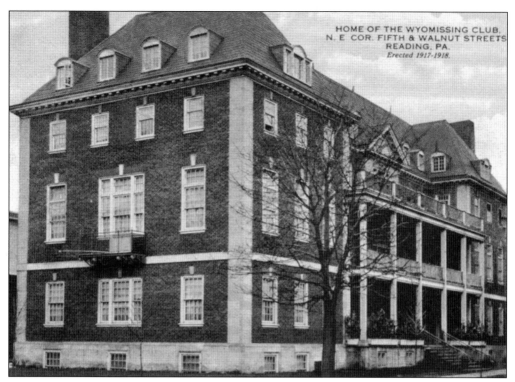

THE WYOMISSING CLUB. Once headquarters of an exclusive downtown social and dining club, the building was restored in 1999 and is now a 62-unit elderly housing project. (H. Winslow Fegley)

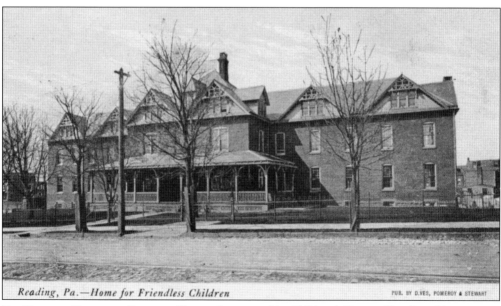

Reading, Pa.—Home for Friendless Children

PUB. BY D.VES, POMEROY & STEWART

THE HOME FOR FRIENDLESS CHILDREN. The predecessor of the Children's Home of Reading, this structure, built in 1888, is located on the Children's Home grounds at Centre Avenue and Spring Streets, across Spring Street from the Historical Society of Berks County. (Dives, Pomeroy & Stewart.)

111

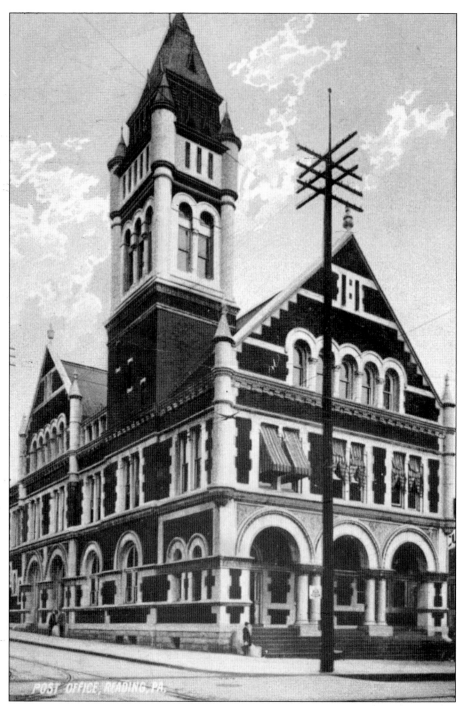

THE POST OFFICE. This ornate structure served as the downtown post office from 1889 until 1938. Also known as the Federal Building in its heyday, the building was demolished to make room for the post office seen in the next picture. In the time between the demolition of this building and the opening of the later structure, the post office operated out of temporary headquarters at 126-128 North Fifth Street. (The Rotograph Company.)

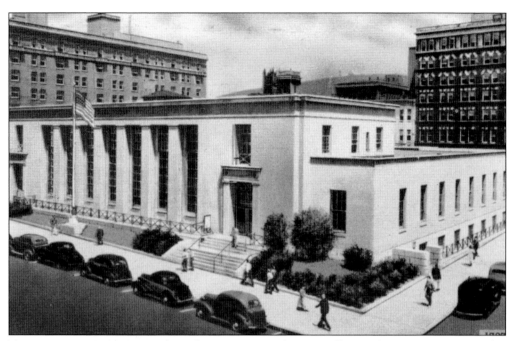

THE NEW POST OFFICE. Erected on the same site as the post office in the previous picture, this building opened in 1939 still serves as a downtown substation of the larger postal facility now located in northeast Reading. (Berkshire News Company.)

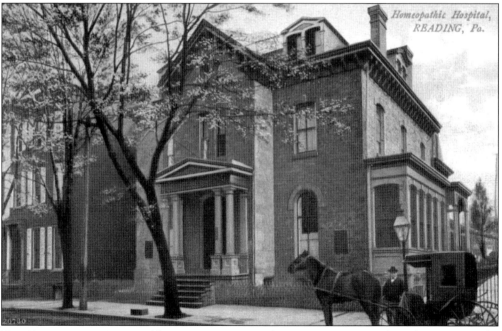

THE HOMEOPATHIC HOSPITAL. This institution opened in 1891 at 135 North Sixth Street, on the site of the present Community Campus of St. Joseph's Hospital. In the 1940s, the Homeopathic Hospital expanded and became known as Community General Hospital. (Souvenir Post Card Company.)

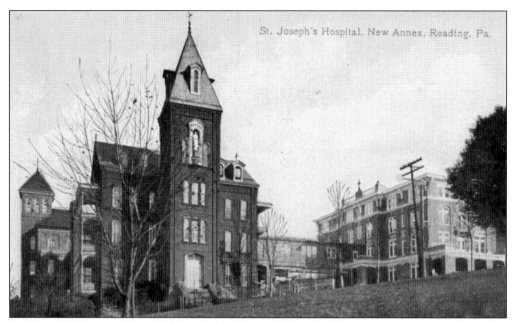

ST. JOSEPH'S HOSPITAL. The 1882 hospital building (left) and 1903 Nurses' Home are seen in this *c.* 1917 view of the hospital taken from City Park. The building on the left still stands, but the Nurses' Home has been demolished. (The Leighton & Valentine Company.)

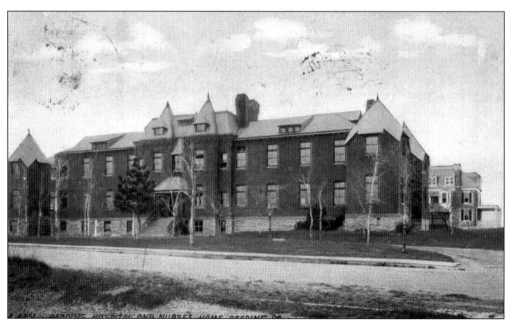

THE READING HOSPITAL. This was the first hospital in Reading, dedicated on June 2, 1886. A large wing was added in 1891 and another in 1911. This building at Front and Spring Streets was razed to make room for Northwest Junior High School. The hospital moved to larger quarters in West Reading (see next picture).

114

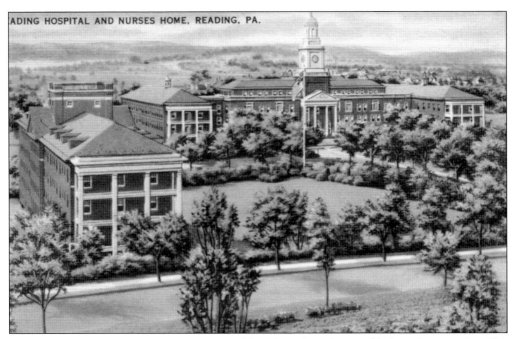

THE READING HOSPITAL. Many new wings and buildings have been added to this complex. The Reading Hospital and Medical Center, opened in 1926, remains one of the largest and busiest hospitals in Pennsylvania. (Berkshire News Company.)

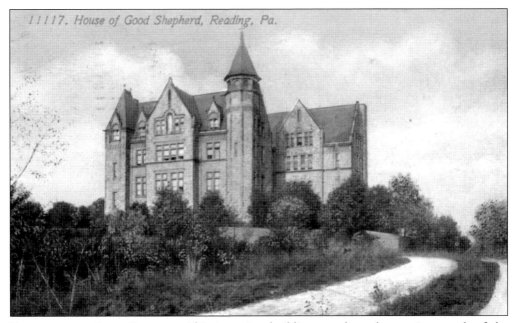

11117. House of Good Shepherd, Reading, Pa.

THE HOUSE OF GOOD SHEPHERD. This imposing building stood on 4 acres just north of the Schuylkill Avenue Bridge in the Glenside section of the city. It served as a Catholic-operated home for troubled girls and a convent. The operation started in 1889 at Fourth and Pine Streets and moved to this building in 1900. (The Acmegraph Company.)

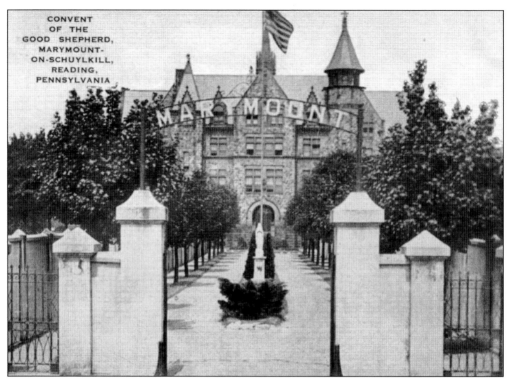

CONVENT OF THE GOOD SHEPHERD, MARYMOUNT-ON-SCHUYLKILL, READING, PENNSYLVANIA

THE HOUSE OF GOOD SHEPHERD, SCENE TWO. The House of Good Shepherd was also known as Marymount-on-the-Schuylkill. This view of the main entrance to the complex was obliterated when the building was torn down in 1970 to make room for the expansion of the adjacent Carpenter Technology Corporation. One contemporary description of the operation described the House of Good Shepherd as a place "where fallen women are reclaimed."

ST. MICHAEL'S SEMINARY. Starting *c.* 1921, the Missionary Sisters of the Most Sacred Heart maintained their mother house here. This Catholic institution was demolished in the 1990s. A retirement home now stands on the site in Hyde Park. (The American News Company.)

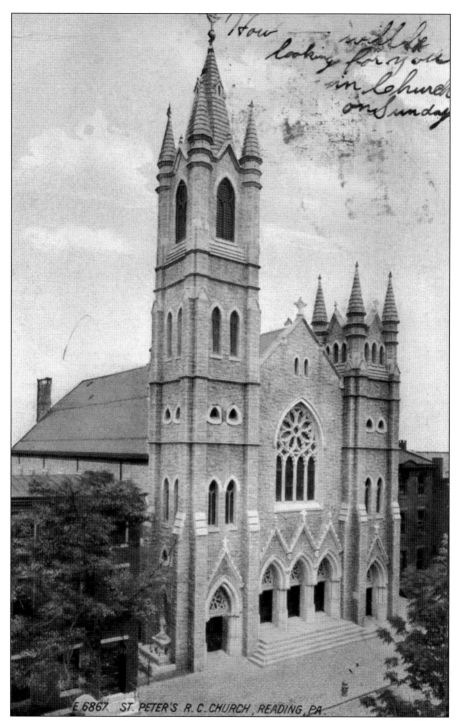

ST. PETER'S CHURCH. A handsome house of worship on South Fifth Street, St. Peter's Roman Catholic Church can trace its beginnings to 1752, when its congregation was organized. The original church on the site was constructed in 1845 and enlarged in 1870. This edifice was erected in 1900.

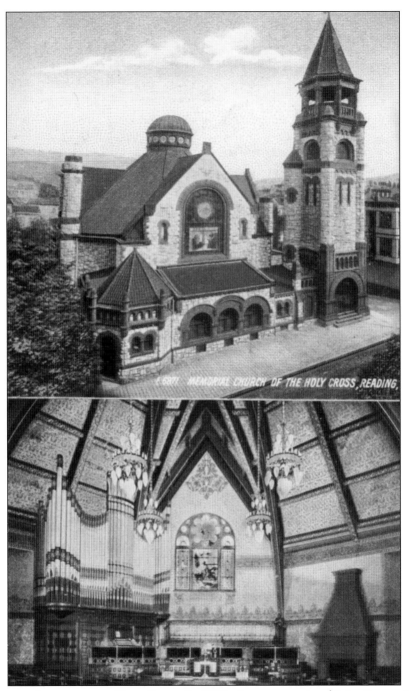

THE MEMORIAL CHURCH OF THE HOLY CROSS. In 1892, the congregation of the former Ebenezer Church began construction of this impressive structure on North Fifth Street. During the construction, the original, massive tower of the building collapsed and was rebuilt. The church was dedicated October 1, 1893. Built with Michigan red stone and crystalline marble and intended to resemble a classic European church, it was designed in the Romanesque style with Gothic and Baroque influences. Among its many unique features is a 100-foot mosaic-paved cloister.

THE CHRIST CATHEDRAL (EPISCOPAL) CHURCH. A landmark in the heart of downtown Reading, this church still stands tall on the northwest corner of Fifth and Court Streets. The building was constructed starting in 1825 and its Gothic style was established during renovations in 1847. Its congregation dates to 1762, making it the oldest English-speaking church in the city. Note the building to the left of the church in this picture. It was the home of U.S. Supreme Court Justice William Strong (1808–1895) and is marked by a contemporary state historical marker. In 1948, that building was demolished and the churchyard was enlarged. A parish house was added in 1959. The congregation began as St. Mary's, named after the Penn family parish in Reading, Berkshire, England. In 1815, it switched to Christ Church, after the church of the same name in Philadelphia. The inclusion of the word *cathedral* in its name refers to the years from 1872 to 1895, when it was the Pro-Cathedral of the Diocese of Eastern Pennsylvania. (A.C. Bosselman & Company.)

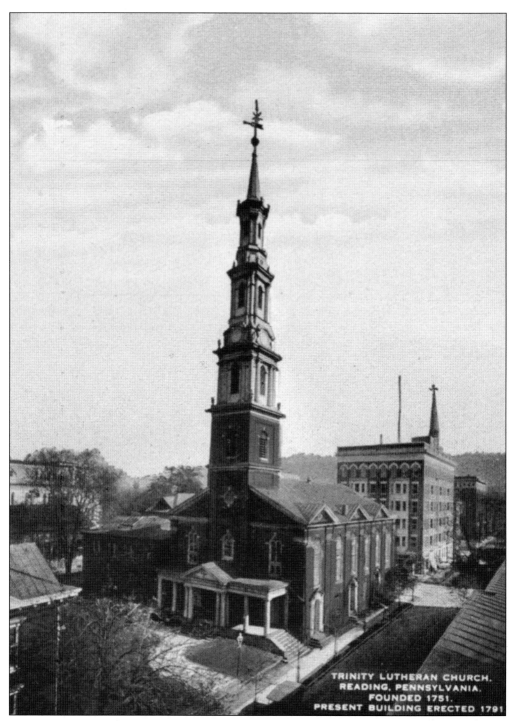

THE TRINITY LUTHERAN CHURCH. Before the construction of this edifice in 1791, the previous (built in 1753) Trinity Church was one of several churches in the city that served as hospitals during the Revolutionary War. Dr. Bodo Otto, who served as senior surgeon of the Continental Army in the American Revolution, is buried in the church graveyard. (H. Winslow Fegley.)

THE ENTRANCE TO CHARLES EVANS CEMETERY. This entranceway was completed in 1852. It is interesting to note that while the approach roadway to the Gothic Revival gateway may appear to be cobblestone, it was actually made of wooden blocks.

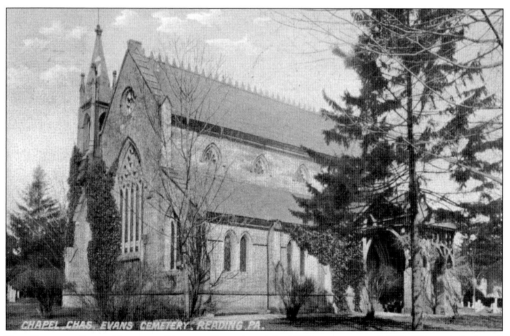

THE CHARLES EVANS CEMETERY CHAPEL. Completed in 1855 at a cost of $18,000 and designed to complement the grand entrance to the cemetery, this brownstone chapel was designed by Philadelphia architect John Gries, who is buried in Charles Evans Cemetery. After suffering severe weather damage in the 1950s, the chapel was demolished. A new chapel was built in its place.

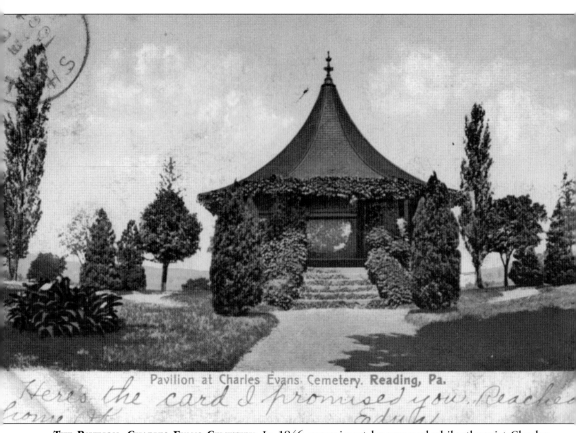

Pavilion at Charles Evans Cemetery. Reading, Pa.

Here's the card I promised you. Reached home at Edw/ (?)

THE PAVILION, CHARLES EVANS CEMETERY. In 1846, prominent lawyer and philanthropist Charles Evans donated 25 acres and $79,000 to establish what is now the largest cemetery (119 acres with more than 7 miles of paved roads) in the city. It is also well known for its landscaping, birding opportunities, and architecture. The lush landscaping of the grounds is evident in this *c.* 1906 view of a pavilion inside Charles Evans Cemetery. (The American News Company.)

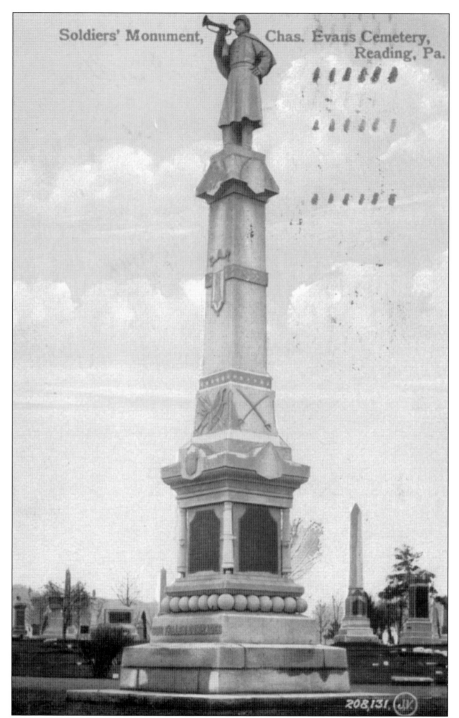

Soldiers' Monument, Chas. Evans Cemetery, Reading, Pa.

THE SOLDIER'S MONUMENT, CHARLES EVANS CEMETERY. Built in 1887 by the Reading area posts of the Grand Army of the Republic (GAR), this memorial stands tall among many others in the heart of Charles Evans Cemetery. At the base of the monument are the names of 244 soldiers who gave their lives during the Civil War. (The Valentine & Sons Publishing Company.)

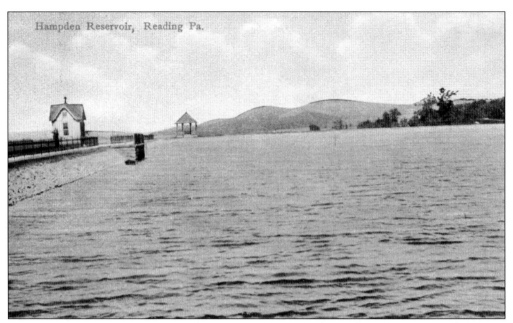

THE HAMPDEN RESERVOIR. Once a major water supply for the city, this reservoir on the slope of Mount Penn along Hampden Boulevard was drained many years ago. Its bottom now serves as playing fields within the city-owned Hampden Park adjacent to Reading High School. (A.C. Bosselman & Company.)

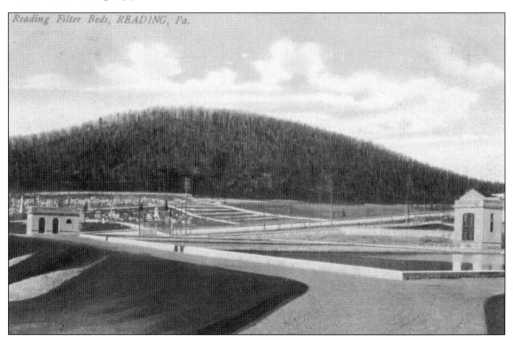

THE READING FILTER BEDS. The southern slope of Mount Penn and a portion of the Aulenbach Cemetery are visible beyond the pump houses of the Perkiomen Avenue filter beds. Water was drained from them many years ago and the land they occupied was sold as this book was being compiled. It is destined to be used for housing. (Souvenir Post Card Company.)

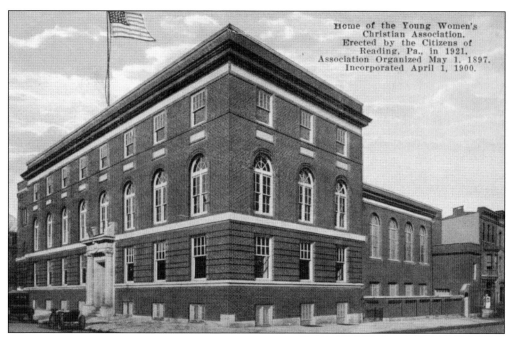

THE READING YWCA. The Young Women's Christian Association was organized in Reading in 1897, chartered in 1900, and moved into this building in 1921. Now converted into multipurpose uses, this former YWCA building still stands on the northwest corner of Eighth and Washington Streets.

THE READING YMCA. The Reading Young Men's Christian Association was established in 1869. For several years before the turn of the 20th century, it occupied a portion of the Breneiser Building at Eighth and Penn Streets. It later moved to 626 Penn Street before occupying this structure on Washington Street, where the YMCA remains today.

THE SCHUYLKILL COLLEGE ADMINISTRATION BUILDING. In 1882, the Schuylkill Seminary of the East Pennsylvania Conference of the Evangelical Church was established in Reading. In 1902, after a brief relocation to Lebanon County, it moved back to the city and underwent rapid growth in ensuing years. In 1923, it became Schuylkill College. Meanwhile, in Myerstown, Lebanon County, an institution called Albright College had been established. In September 1928, the Reading and Myerstown colleges were merged and the result is the present Albright College in northeast Reading.

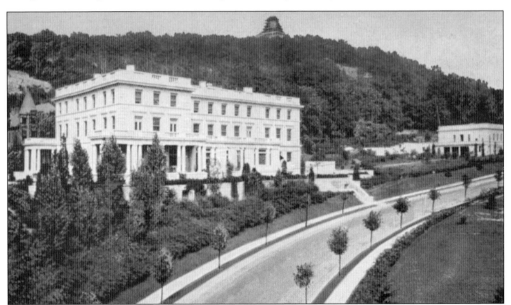

BON-AIR. William H. Luden started making candy in the back of his father's jewelry shop at 35–37 North Fifth Street in 1879. His efforts proved quite popular and successful, and by 1900 Luden's Candy moved into a large complex that still exists as a division of the Hershey Foods Corporation at Eighth and Walnut Streets. This was Luden's mansion at Hill Road and Clymer Streets, known as Bon-Air. It is now the Reading Central Catholic High School.

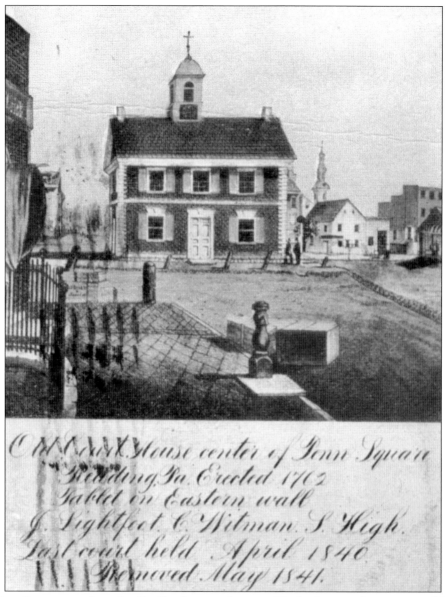

C[OURT] House center of Penn Square
Reading Pa. Erected 1762
Tablet on Eastern wall
J. Lightfoot, C. Wilman, S. High.
Last court held April 1840.
Removed May 1841.

THE OLD COURTHOUSE. Just after Reading became the seat of Berks County when it was established in 1752, the first transactions of the judicial system and county business were held in taverns. In 1758, a special tax was levied to raise funds for construction of the first official Berks County Courthouse. That building was placed in the center of Penn Square and was completed in 1762. A two-story limestone building measuring 40 by 50 feet, its main entrance was on the south side and its first floor was consumed by the courtroom. The town clock, made in London in 1755, and a bell, also made in London in 1763, were placed in the tower of the courthouse. On July 8, 1776, that bell became "Reading's Liberty Bell" when it tolled to call the residents together so that they could hear Sheriff Henry Vanderslice read the Declaration of Independence. The last gavel went down inside this building in April 1840, and a larger courthouse (see previous picture) was built at Sixth and Court Streets. The Penn Square courthouse was demolished in the summer of 1841.

EPILOGUE

While it has been long conceded that the first picture postcards as we know them were sold in the United States at the Columbian Exposition in Chicago in 1893, the copyright of the first private postal card has been traced to John Charlton of Philadelphia in 1861. Note the term *postal card*. Only the federal government was allowed to use the word *postcard* until 1901. Before then, cards were called souvenir mail cards or postal cards. Until 1907, it was illegal to write anything on the address side of any card.

Postcard collectors, or deltiologists, have grouped the development of cards into seven periods. Using the 1893 Columbian Exposition as a baseline, the Pioneer Era continued through to 1898 when illustrations were printed on the reverse of the pre-stamped, one-cent government cards and "souvenir cards" were printed by private entrepreneurs and required twice the postage.

From 1898 through 1901, after the manufacturing of commercial cards was permitted by government postal authorities, the Private Mailing Card Era unfolded. Remember, however, that no writing was yet allowed on the address side of the cards. By 1901, publishers across the nation scurried to enter the postcard-printing business, and private citizens experimented with attaching actual photographs to the "back side" of postcards. That 1901–1907 period is called the Postcard Era or the Undivided Back Era.

Following that period, the *Divided* Back Era emerged after Congress approved the writing of messages on the left side and the address on the right side of the divided reverse of picture postcards. From 1907 to 1914, the production of picture postcards exploded. From 1915 to 1930, however, there was an effort to save ink, and many cards were printed with wide borders around the illustration. This period was therefore called the White-Border Era.

The postcard industry was revitalized, and the look of postcards was revolutionized when a new paper-making process allowed cards to be printed on high rag-content stock that vaguely resembled art canvas or linen. Thus, the Linen Era was ushered in c. 1930 and continued into and beyond the 1940s.

The latest transition in postcard production resulted in the "chrome" cards, which continued to be marketed to the time this book was published. The off-the-rack postcards distributed at the start of the 21st century have changed little since then.

There well may be an eighth era in store for postcards. The dawn of the new century may also have cast a new light on the age-old practice of sending a colorful postcard to a good friend, neighbor, or relative—perhaps later to be known as the Internet Era. And, while no "post" is required and no "card" is actually sent, the process of sending "postcards" through cyberspace has taken a life of its own on the computers of people around the world.